The Wonderful World of
Albert Kahn

THE WONDERFUL WORLD OF ALBERT KAHN

COLOUR PHOTOGRAPHS FROM A LOST AGE

David Okuefuna

BOOKS

Contents

Foreword 6

Introduction 8

1 **Western Europe** 18
2 **The Americas** 80
3 **The Balkans** 98
4 **The First World War** 130
5 **The Far East** 184
6 **Indochina** 228
7 **The Middle East** 260
8 **Africa** 280
9 **Portraits** 310

APPENDIX 1
The Autochrome Process 320

APPENDIX 2
Albert Kahn:
The Man and His Legacy 324

Index of Countries 332

Additional Captions 333

Sources and Further Reading 334

Acknowledgements 335

Foreword

Colour images have changed the way we see the world. The defining moment came when we saw our own blue planet from space – and, indeed, from the moon. That magnificent image now represents our shared global destiny.

But our world had first been shown in colour some time before. At the beginning of the twentieth century – when the Earth still seemed so vast and was not yet fully explored and mapped – the French banker Albert Kahn sent teams of cameramen to every corner of the globe. They brought back unique testimonies of human life, in colour photographs and on film. These were not works of reportage or ethnography, nor an attempt to produce works of art. The aim was simply to record human beings in all their diversity, living humble lives worthy of respect. And from this respect would, Kahn hoped, arise the universal peace to which he aspired. Kahn's lifetime was not a happy one for a pacifist, since it included three terrible wars that involved his homeland. Yet he retained his faith in humanity and believed firmly in his mission, pursuing it to the full.

The BBC and the Musée Albert-Kahn have joined forces to bring this ode to life and humanity to a wider public. From a fertile exchange of experience and expertise has come a series of television documentaries, a book and DVDs that reflect our shared ambitions. They also mark fifty years of effort by the French *département* of Hauts-de-Seine, owner of the Kahn collections, to preserve and enhance awareness of this exceptional heritage. Today, thanks to the combined talents of the BBC teams, David Okuefuna, BBC Books and the museum team, this piece of the world's memory has been restored to its full glory, in several languages and formats, for everyone to see.

It is understandable that the BBC would take an interest in the work of Albert Kahn, since his work is addressed to everyone, regardless of their own culture or time. The year 1922, when Kahn's influence and work were reaching their peak, saw the birth of the BBC, with its ambition for nation to speak peace unto nation. Albert Kahn would have given his full support to this important mission, taken up by an institution that was founded, like his own brainchild, on cutting-edge technology of the day. Now the meeting of minds and sharing of know-how has taken place, and the torch of a universal humanism served by the high technology of our own times has been passed to the entire planet.

Gilles Baud-Berthier
Director of the Musée Albert-Kahn, France

◀ A Parisian flower-seller's cart in 1912 – one of Albert Kahn's early autochrome tests. A131 (detail)

Introduction

In the history of visual culture, the summer of 1907 is usually remembered for the moment that Pablo Picasso unveiled one of the most important paintings of the twentieth century. A dramatic, dynamic portrait of five prostitutes cavorting in a brothel, *Les Demoiselles d'Avignon* introduced to art a distinctively modern view of the world – and earned its creator near-universal critical opprobrium and notoriety in equal measure.

But at precisely the same time, and in the very same place, another revolution was unfolding. On 10 June 1907, at the offices of the newspaper *L'Illustration* in Paris, the sibling inventors Auguste and Louis Lumière gave the first public demonstration of what they called the autochrome. This technology, which was based on a granular compound consisting largely of potato starch, made it possible to produce true-colour photographs with a standard glass-plate camera.

The autochrome was rapturously received: viewers were captivated by the ethereal beauty of these images. Just like Picasso's pink, prancing prostitutes, the Lumières' invention of user-friendly colour photography would prove to be a critical development in modern visual culture. By exploiting nothing more exotic than the humble *pomme de terre*, the Lumière brothers would inaugurate a new era in the medium

▲ Louis Lumière, one half of the fraternal partnership that invented the autochrome process, photographed in Boulogne on 17 June 1930. A63087 Georges Chevalier

◄ The normally camera-shy Albert Kahn outside his office in the rue de Richelieu in Paris in 1914, on the only occasion he agreed to pose formally for the camera. I135X Georges Chevalier

of photography: the Age of Colour. As the eminent American photographer Alfred Stieglitz prophesied, 'The possibilities of the process seem to be unlimited. Soon the world will be colour-mad – and Lumière will be responsible.'

Stieglitz was not the only one to recognise the exciting potential of the autochrome. The banker and

▲ Seen here on 20 May 1929, this mansion at rue du Port in Boulogne-Billancourt on the outskirts of Paris was rented by Albert Kahn in 1893. Two years later he purchased the house and the surrounding estate. B1734 Auguste Léon

philanthropist Albert Kahn was himself almost pathologically camera-shy – a distinction, incidentally, that he shared with another giant figure in French photographic history, Henri Cartier-Bresson. Yet it is evident that Kahn was fascinated by the medium of photography, and intrigued by the Lumière brothers' ingenious technological breakthrough. With the arrival of colour, Kahn realised that photography was standing at the threshold of a new world of creative possibilities. Moreover, he saw that the autochrome could be the instrument that would help him to achieve a cherished political ambition.

As a fervent internationalist and pacifist, Kahn yearned to discover ways to prevent conflict between nations. For many years he had hosted weekly sessions at his elegant estate in Boulogne-Billancourt near Paris, where prominent members of Europe's political, business, cultural and academic elites gathered to discuss world affairs. He had become convinced of the importance of the propagation of knowledge: more specifically, he believed that an increased appreciation of the cultural diversity of our world represented the best hope of averting the horror of war.

There seems little doubt that Kahn's pacifist impulses stemmed from a single formative childhood experience. Born in 1860, Albert (then known to his family as Abraham) grew up in the town of Marmoutier in Alsace in eastern France. His father, a Jewish livestock trader, gave the young Albert a comfortable (though far from privileged) upbringing. The early years of Kahn *fils*, it appears, were ones of largely uneventful contentment. But all that changed in 1870. Following a diplomatic spat over the Prussian Prince Leopold of Hohenzollern's candidacy for the Spanish throne, on 19 July France declared war on Prussia. But the move was ill advised: the French were able to mobilise only two hundred thousand troops – half the number that

Prussia had at its disposal. By September the French had been routed, and the Prussian army had the ruler of France, Emperor Napoleon III, in custody. Albert Kahn's beloved France lay at the mercy of the imperious Prussian Chancellor, Otto von Bismarck. After French resistance ended in May 1871, Prussia, by then the dominant political entity within the German empire, annexed Alsace together with the neighbouring territory of Lorraine. Overnight, the eleven-year-old schoolboy became one of the thousands of new French-speaking subjects of the German Kaiser.

We can only speculate on the effect that the traumatically abrupt annexation of the land of his birth had on the temperament, disposition and political persuasions of Albert Kahn. What is certain is that within five years he had resolved to make a life for himself outside his new German homeland.

At the age of sixteen he arrived in Paris, where he eventually found work as an apprentice at a bank owned by a family friend, Edouard Goudchaux. It seems Kahn was a shy, near-reclusive figure: nevertheless, he established himself as bright, ambitious and capable. By the mid-1880s, he had persuaded his employers to commission him to broker a series of deals in South Africa, including investments in the

▲ A youthful Albert sits amid the rigging, as his cousin Léopold looks on. Kahn adored the ocean: he bought three properties that overlooked the sea. Georgette Kahn collection

gold and diamond mines operated by the famous empire-builder Cecil Rhodes. These ventures proved extraordinarily lucrative for Goudchaux – and for Kahn. By 1895, he was wealthy enough to acquire the 10-acre estate he had been renting in Boulogne-Billancourt. Still in his mid-thirties, he was already a self-made millionaire. But it is evident that, for Kahn, the pursuit of money was not some all-consuming obsession. Although he was a man of means, he was also a man with a mission.

Soon after his arrival in Paris, he had enrolled on a degree course. As part of his studies he was taught by the brilliant young philosopher Henri Bergson.

▲ Kahn's great friend, the philosopher Henri Bergson (1859–1941), photographed on 27 June 1917. A10589 Auguste Léon

Throughout their lives, Bergson – who won the Nobel Prize for Literature in 1927 – exerted a profound intellectual influence on Kahn. As the historian Jay Winter has observed, Kahn 'had a metaphysician's temperament, a taste for philosophical speculation about the quest for peace to which he returned throughout his later life. Kahn committed his fortune to educating people who lived in confined national frameworks to see the challenges and dangers of a world much more unified than ever before.'

By 1898, Kahn was already demonstrating his willingness to put his private fortune to philanthropic purpose. He established his Bourses de Voyage Autour du Monde – a scholarship programme that awarded grants for foreign travel to young academics. Kahn believed that by enabling teachers to experience the diverse cultures of the world, he would have a progressive impact on those who would mould the minds of the young in the years to come. Through the scheme (which, interestingly, was established four years *before* the more famous scholarship programme endowed by Cecil Rhodes) Kahn gave scores of young people from France, the United States, Britain, Germany and Japan the opportunity to travel the world and broaden their minds.

In our more cynical age, the idea that exposing individuals to the world through travel would promote international understanding and thereby make the world a better and more peaceful place might seem hopelessly utopian and naive. But in *fin de siècle* Paris, where the caustic whiff of anti-Semitism emanating from the Dreyfus Affair was still swirling in the air, the need to do something to overcome national narrow-mindedness and ethnic hatred must have seemed pressing to those of more progressive political persuasions. So when Kahn learnt of the invention of the autochrome, which made colour photography portable for the first time, he believed that he now had at his disposal another educational tool that could help to promote his internationalist and pacifist convictions.

Kahn acquired his first consignment of autochrome plates in the summer of 1908. The images they produced were shot by Kahn's chauffeur and travelling companion Alfred Dutertre (1884–1964)

▲ Albert Kahn's much-loved Japanese garden at his home near Paris in 1911. B123 Auguste Léon

during a round-the-world trip that took them to the United States, Canada, Japan and China. Relatively few of these images have survived, but those that have are some of the earliest known true-colour pictures taken in each of these countries. It is likely that, during this circumnavigation of the globe, Kahn devised his plan to create what he called his Archives de la Planète (Archives of the Planet) – a monumentally ambitious attempt to produce a photographic record of human life on Earth.

For the next twenty-two years, Kahn used his private fortune to recruit professional photographers, supply them with trunk-loads of autochrome plates (and often ciné film cans as well) and dispatch them all over the world. During these journeys – undertaken before the creation of the long-haul transport systems we take for granted today – Kahn's photographers recorded in intimate detail the lived experiences and cultural practices of thousands of ordinary people from across the globe.

Often, Kahn's photographers visited these countries at crucial junctures in their modern history. In Europe they witnessed wars that would create new states in the Balkans. They lived among the French soldiers – and their comrades from the French colonies – who were fighting on the Western Front. They joined the raucous celebrations in Paris following the signing of the Armistice in 1918.

Throughout the 1920s, Kahn's photographers watched the peoples of Asia and the Middle East as they strode towards self-determination. Their pictures record the efforts of modernising nation-builders, such as Mustafa Kemal (otherwise known as Atatürk) in Turkey and Emir Faisal of Syria and Iraq, who would reshape the political destiny of their peoples by leading their countrymen towards independence.

The Archives' films and autochromes chronicle a period that saw the destiny of the Arab world reshaped by the discovery of vast oilfields – a factor

▲ Albert Kahn's palatial home overlooking the sea at Cap Martin on the French Riviera, c.1910. C70

that transformed the economic and strategic position of the region overnight. Kahn's cameras recorded reactions in Palestine to the visit by the British Prime Minister Arthur Balfour, who had committed Britain to support the creation of a Jewish homeland. His photographers visited Persia (now Iran) just after the military coup that brought the new Shah to power; and they captured life in Afghanistan in the years after the Third Anglo-Afghan War. Further east, Kahn's cameras recorded a nation mourning the loss of an Emperor in Japan; and the exuberant spectacle of a Maharajah's jubilee in India.

In Asia, many of the images captured by Kahn's photographers document a disappearing world.

Across the globe, cultures and traditions were being erased by the relentless encroachment of European influence. In Africa, the Middle East and Asia, ways of life were undergoing wholesale homogenisation, as languages, religious practices and dress conventions succumbed to the imposed cultural supremacy of the colonial powers. Remarkably, more than half a century before the term was invented, Kahn was fully aware of the destructive potential of what we would now call 'globalisation': at least part of his intention was to record the vital, distinctive aspects of the world's vulnerable cultures before they would vanish for ever.

After a close inspection of the images produced by Kahn's *opérateurs,* it is possible to draw a number of conclusions about the early years of the twentieth century. For many people in the countries they visited, life was a brutal combination of poverty, privation and pain. Kahn's project had been conceived, launched and largely conducted in an age that the writer A. N. Wilson has described as '[a] period of history in which human beings massacred one another in numbers without historical parallel'. In the years before a catastrophic world war, a series of localised conflicts pitted Britons against Boers,

Americans against Filipinos, Japanese against Russians, Italians against Libyans, Ottomans against Macedonians (and Greeks, Bulgarians and Serbs), not to mention democides aplenty in countries as diverse as China, Russia, South-West Africa (now Namibia) and the Congo. As an avid newspaper reader, Kahn must have been aware of the global ubiquity of violence. Indeed, it might have been the experience of

▼ Guests face the camera while standing outside Kahn's residence at Cap Martin in January 1910. C45

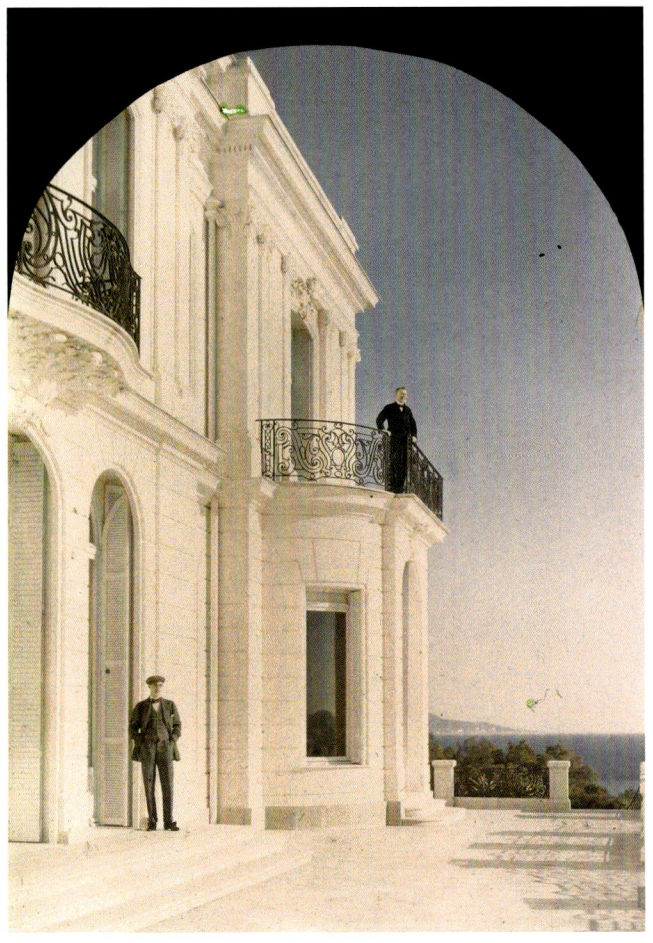

war in his youth and his awareness of troubles around the world that prompted him to create the Archives of the Planet in the first place. As Jay Winter speculates, 'Was it the racial exploitation behind the hugely profitable extractive industries in the Cape, or the bloodshed of the Russo-Japanese war, that led him to fear for the future if productive forces were not harnessed to peaceful ends? Or, perhaps, did he suffer a *crise de conscience* in the 1890s, which led him to reconsider his beliefs and his mission in life?'

Whether he was incited to action by a spasm of guilt about the origins of his fortune, or by an abstract philosophical commitment to a utopian principle, there is no question that Kahn's creation of the Archives of the Planet was an extraordinarily ambitious (and massively expensive) enterprise. Yet, undaunted by the huge cost, he bankrolled the project for more than two decades. Kahn must have expected to have the financial wherewithal to sustain it indefinitely. But global events delivered a hammer-blow to his plans. At the start of 1929, Kahn was presiding over a financial empire of enviable robustness. A respected financier renowned for his deft handling of inter-governmental loans, he had become the proprietor of his very own bank. Yet by the end of that year, the Wall Street Crash had reduced one of the most successful bankers in Europe to something approaching penury.

Despite the increasingly precarious state of his finances, in the years after the Crash Kahn refused to abandon his cherished photographic project

entirely. The missions continued, albeit in a reduced form, well into the 1930s. But expeditions to the more far-flung destinations ceased. Apart from a solitary mission to West Africa in 1930, his photographers would never again journey beyond the Mediterranean.

By the mid-1930s Kahn was bankrupt, and was forced to sell his Boulogne estate. Eventually it was acquired by the local authority, who kindly allowed Kahn to live on at the place that had been his home for more than four decades.

In 1870, as a boy growing up in Alsace, Kahn had lived through one German invasion: seventy years later, he witnessed another, as Hitler's *Wehrmacht* swept through France and occupied Paris. War – the abomination that he had tried so hard to eliminate – had visited itself upon his homeland once again. But Kahn avoided the fate of more than seventy-five thousand of his fellow French Jews who perished in the Nazi death camps. On the night of 13–14 November 1940 he died in his sleep. At eighty, the avowed pacifist had found peace at last.

The five years that followed his death would see Pearl Harbor, Stalingrad, Auschwitz and Hiroshima burnt indelibly into the chronicle of horror that is the twentieth century. Kahn's pacifist mission might

▲ Kahn's retreat at Carbis Bay near St Ives in Cornwall in August 1913. It was demolished in the 1970s. A2325 Auguste Léon

have failed spectacularly, but his project was by no means futile. By the time his operations were wound down, he had secured a significant place in the history of both photography and cinematography. His Archives of the Planet had assembled a collection of images that provide a unique insight into the formative years of the twentieth century. It contained around 120 hours of rare documentary film footage from around the world; it boasted a 4000-strong collection of original black-and-white still photographs; and it possessed a precious, multi-coloured treasury of more than 72,000 autochromes. Albert Kahn had amassed what is indisputably the most important collection of early colour photographs in the world.

▲ Guests in the gardens of Kahn's cliff-top residence in Cornwall photographed on 25 August 1913. A69862 Auguste Léon

This book is intended to complement the BBC documentary series *Edwardians in Colour* and *Twenties in Colour: The Wonderful World of Albert Kahn*, which were first broadcast in the United Kingdom in 2007. In the introductions to each of the chapters I have tried to provide a concise overview of the historical context in which Kahn's photographers conducted their missions. Where they exist, I have also used documentary sources (particularly letters and diaries) drawn from the Archives at the Musée Albert-Kahn to offer readers a sense of the experiences these pioneering *opérateurs* had during their travels.

But primarily, this book is a showcase for some of the finest autochromes in the extraordinary collection held at the museum. To accompany the pictures I have written a series of thumbnail captions, based on the information contained in the registers that list these autochromes. Invaluable as they are, however, the entries in these registers offer few details other than the name of the *opérateur* and the date and place the image was produced. Almost invariably, there is a description consisting of just a few words on the scene captured. Sometimes Kahn's photographers name those who appear in their shots: more often, identities remain obscure. Furthermore, researching these images is made even more challenging because of inconsistencies in the way they were originally logged. Each plate has been given a unique number, but these numbers do not increase in strict correlation with the chronological order in which the images were produced: autochromes with low numbers were not necessarily shot before those with a very high number, or vice versa. In many cases, where crucial information is unavailable, I have included supplementary information – and, sometimes, informed speculation – that I consider relevant. I hope these captions will deepen and enrich the viewing experience for those seeking to interpret the scenes frozen on Kahn's glass plates.

1 Western Europe

Conceived in France by a man of cosmopolitan tastes and internationalist persuasions, Albert Kahn's Archives of the Planet always embraced the global: from the outset, it was a project that sought to look beyond the limited horizon of its European origin. Nonetheless, of all the biases in the Kahn collection, the most apparent by far is its geographical Eurocentricity. More than half of all the missions undertaken by Kahn's photographers were conducted east of *La Manche* and west of the Bosphorus.

This is hardly surprising. Twenty-first-century travellers routinely bemoan the discomforts and bureaucracy of the modern airport. But when Kahn's *opérateurs* were at their most productive, the logistical challenges confronting those daring enough to countenance the possibility of intercontinental travel faced problems of an entirely different order. Since Kahn's photographers could not avail themselves of modern long-distance transport facilities, it is only to be expected that a disproportionate number of missions would be conducted relatively close to home.

Given what might be called the Kahn Archives' occidental orientation, it was a stroke of luck that the project was operating at an especially auspicious juncture in European history. By the time the Continent's leaders submerged Europe in a conflict that would slaughter great swathes of their own

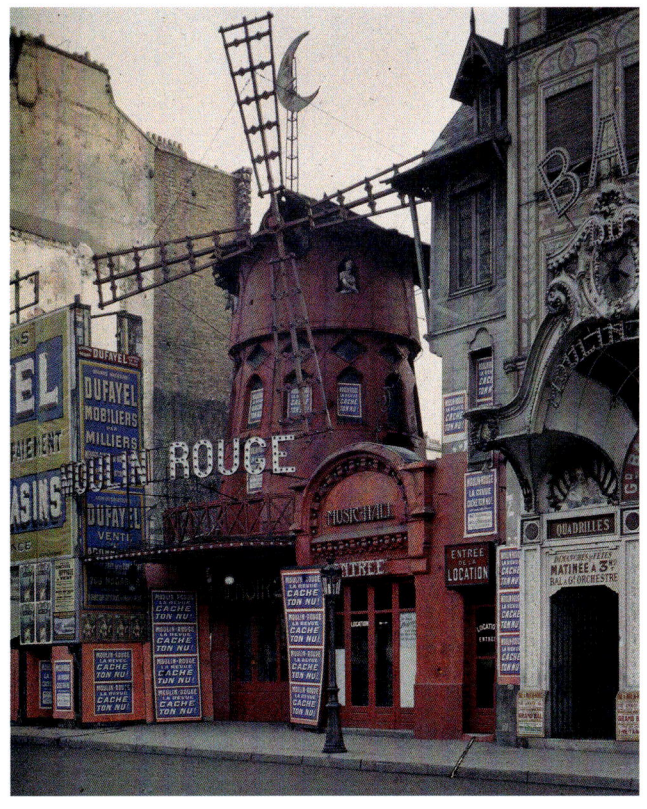

▲ The Moulin Rouge nightclub in Paris, home of the scandalous can-can, photographed in July 1914. A7462 Stéphane Passet

◀ Taken in August 1913, this timeless image of a Cornish haycart is somewhat redolent of rural scenes described in the Wessex novels of Thomas Hardy. A2352 (detail) Auguste Léon

populations, Kahn's photographers had already visited the countries we know today as France, Sweden, Norway, Britain, Ireland, Spain, Portugal, Switzerland, Italy, Greece, Austria, Hungary, the Czech Republic,

▲ The Director of the Archives of the Planet, Jean Brunhes (left), in 1922, and Kahn's long-serving photographer, Auguste Léon, with his daughter in 1918. A33818 (left) and A14552

Serbia, Macedonia, Albania, Montenegro and Bulgaria. If the launch of Kahn's enterprise was timely, no less shrewd was the selection of his intended destinations. The 1913 expedition to the Balkans by the Director of the Archives, the eminent geographer Jean Brunhes (1869–1930), together with its longest-serving professional photographer, Auguste Léon (1857–1942), was extraordinarily prescient, since events in the region, including the assassination of Archduke Franz Ferdinand in Sarajevo, were about to take on world-historical importance.

It is generally accepted that in the years before 1914, when the four-year bloodbath began, life in much of western Europe was comparatively tranquil, prosperous and progressive. French and British rule over their respective empires was unchallenged. The great capital cities were experiencing a *fin de siècle* flowering of avant-garde movements in the arts and vital breakthroughs in science and technology. In Europe's collective historical memory, images of bohemian decadence, *belle époque* elegance and Edwardian opulence still prevail. For most men of means, such as Albert Kahn, it must have been tempting to become immersed in the aesthetic, intellectual or sensual pleasures of the time. But clearly, Kahn was among those who recognised that there was another, more troubling facet to this supposedly gilded age.

As is evident from many of their pre-war films and photographs, Kahn and Brunhes had pressed their *opérateurs* to search for the grittier realities of everyday life. Brunhes had issued the *autochromistes* with guidance notes, which invited them to seek out distinctive aspects of the local landscape, architecture, culture and so on. But he also ordered the photographers not to adhere slavishly to his desiderata: they were given carte blanche to photograph anything else that caught their eye. As a consequence, Kahn's collection of images from Europe can seem

bewilderingly disparate. Take the autochromes shot by Auguste Léon during his two separate visits to Britain in 1913. From London, there is a series of picture-postcard images of, *inter alia,* Buckingham Palace, the Royal Courts of Justice and St Paul's Cathedral. They are joined by the pictures he had assembled in Cornwall just a few weeks earlier: a series of delicate, intimate and evocative images showing children at play – and, in that less enlightened age, at work; farmers still driving horse-drawn hay carts; and an old sea-dog smoking his pipe outside his white-walled cottage, looking a little stranded now he finds himself washed ashore.

Léon's starkly beautiful pictures of the villages lining the Cornish coast feel only distantly related to the scenes of self-confident imperial grandeur that were so conspicuous during his tour of Edwardian London. In external appearance, the vernacular architecture of Cornwall seems to possess a much closer kinship to the buildings photographed by another of Kahn's *opérateurs* – the only woman to be sent on assignment by the Archives of the Planet.

Marguerite Mespoulet (1880–1965) arrived in Ireland in the spring of 1913. An academic who had already been the beneficiary of one of Albert Kahn's travel grants (thanks to his generosity, she had visited Japan in 1907), Mespoulet was accompanied on her Irish adventure by another of Kahn's *boursiers*, Madeleine Mignon (1882–1976).

As a photographer, still less an *autochromiste,* Mespoulet had limited experience. But she was blessed with genuine flair. Invariably, her studies of impoverished farmers, fishermen in coracles and toiling peat-diggers in the west of Ireland are subtly composed and intensely poignant. Yet it is Mespoulet's pictures of women that are, to the modern eye

▼ In August 1913 Auguste Léon's camera captured a veteran mariner who has found dry land near Kahn's holiday home at Carbis Bay on the north coast of Cornwall. A2405

at least, the most engrossing. In a series of portraits taken in the Claddagh, near Galway, she captures the pride, independence and resilience of the local women. Yet her frames never veil the cold, corrosive poverty in this bleak outpost on the Irish periphery.

According to Mespoulet's diary, extreme poverty was not the only threat to the lives of the women in the west of Ireland: she reports that in some of the communities she visited, many people were stricken with typhoid.

▼ This Irish fringe-maker earned 3s 6d (17½ pence) for each shawl fringe she produced. It took three days to make just one – and she supplied the wool. A3649 Marguerite Mespoulet

After a long sequence of emigrations to the United States, large parts of the Irish population had already ebbed across the Atlantic. In one diary entry, Mespoulet laments, 'The young men leave for North America, the young women too, and when the old people die, the houses are abandoned and fall into ruin. There is hardly a village where one doesn't find sad skeletons of little grey houses invaded by nettles.'

But Ireland was by no means the only nation suffering from huge population outflows: similar demographic developments had also depleted the communities of Sweden and Norway. Today, the Scandinavian nations enjoy some of the highest living standards anywhere on earth. But when Albert Kahn joined Auguste Léon on a motoring excursion through the peninsula in 1910, its rural communities had only recently experienced the combined effects of large-scale transatlantic emigration, failed harvests, widespread destitution and, ultimately, famine.

Unlike Mespoulet's portrayal of Ireland, Léon's Nordic autochromes betray little of the social and economic traumas that were afflicting the people on the other side of his lens. With a few important exceptions, his pictures are reassuring and

▲ Top: Auguste Léon captures Kahn, on the right of frame, gesturing to boaters on a lake in Norway in 1910. Above: The resulting autochrome. A322 Auguste Léon

▲ These girls' colourful clothes contrast sharply with the sober attire of this yeoman resident of the town of Leksand in Dalarna, photographed on 28 August 1910. A419 Auguste Léon

celebratory. Many of his portraits seem carefully constructed, with people looking posed, and poised, in their Sunday best.

Since 1814, Norway had been ruled by Sweden. But, after several years of agitation for independence within Norway, the political union was finally dissolved in 1905. Happily, this constitutional change was peaceful and orderly; but in the opposite corner of Europe, as Kahn's *opérateurs* would discover, the journey to national self-determination would be much more destructive – and deadly.

Léon's images seldom suggest that he has caught his subjects spontaneously, or in mid-action. Occasionally, though – notably in a terrific sequence of photographs shot in the deceptively idyllic-looking landscapes of rural Sweden – he did manage to

▲ Wet clothes hang from the drystone walls of some of the 1500 celebrated *trulli* houses of Alberobello near Bari, Italy, seen here on 30 September 1913. A2661 Auguste Léon

create several vignettes depicting the everyday lives of the working folk of rural Scandinavia. Considered as a whole, Léon's Nordic portfolio is one of the most moving, evocative and enchanting in the Archives of the Planet.

What is striking about Kahn's pre-war autochromes from Scandinavia, Britain and Ireland is the heterogeneity of northern Europe – especially in the way people dressed. In an age before the international hegemony established by the tailored English suit – or the more recent cultural universality of American sportswear – distinctive national costumes prevailed. It is impossible to confuse the lush red bodices of the traditional Swedish *Folkdrakt* costumes with the vibrant crimson shawls of the colleens of the Claddagh, or, for that matter, the muted, blue-grey tones predominant in the clothes worn by the people Auguste Léon encountered on the next leg of his European tour.

On 18 September 1913, fifteen days after leaving London, Léon arrived in Milan. For his fortnight-long Italian shoot he was accompanied by the Archives of the Planet's Director, Jean Brunhes. Once again, they had arrived in a country in the throes of profound economic and political change. Up to this point, Italian men who were unfortunate enough to be either uneducated or poor had been denied the vote. But in 1913, new laws enfranchised all adult males. (Italian women, like their sisters in Britain, Ireland and France, were still excluded from the democratic process.) Italy shared with Ireland and Scandinavia the socially debilitating effects of a prolonged period of population loss. By the end of the nineteenth century, an estimated 1 million Italians had left the country to escape the desperate poverty afflicting rural communities, particularly those in the southern half of the peninsula.

After Milan, Léon and Brunhes journeyed through some of Tuscany's most elegant and ancient cities, towns and villages, including Florence, Poggibonsi, Siena, Monteriggioni and San Gimignano. They continued south, via the elegant city of L'Aquila in the Abruzzo region, before arriving at the remarkable town of Alberobello. Unlike the staple destinations of the Grand Tour, such as Florence or Venice, at the time the Frenchmen arrived this part of Italy saw relatively light tourist traffic. Most of the stone-roofed, tepee-shaped *trulli* were then still in use as family homes. Today, many have been converted into commercial concerns: they are souvenir shops, cafés or even small hotels, servicing the thousands of tourists who now visit this idiosyncratic medieval settlement. In Léon's autochromes, the town's only human presence is that of its own residents; outside their houses we see their laundry hanging from clothes-lines, rather than the near-ubiquitous displays of tourist gimcrack there today.

On 1 October the travellers motored towards their final Italian destination: the port of Bari. The very last autochrome they shot there is one of the most touching of all those autochromes produced on this trip. A group of bedraggled children cluster before Léon's camera, corralled into position, presumably, by the severe-looking adults at the rear.

From a twenty-first-century perspective, many of Kahn's pre-war autochromes offer a reassuringly optimistic depiction of western Europe. Evidence of hardship, if not outright poverty, is discernible throughout the collection; but with the exception of their pictures of the Balkans, Kahn's collection reveals a Europe that is, broadly speaking, innocent and at peace with itself. Of course, the historical

▼ Children and adults cluster in front of the thirteenth-century Swabian Castle at Bari on Italy's Adriatic coast on 1 October 1913. A2675 (detail) Auguste Léon

shadows of Passchendaele and the Somme do not encroach on those autochromes that were shot before the nauseating horrors of the Western Front. Inadvertently, Kahn's *opérateurs* had produced a photographic memento mori for a doomed age.

As might be expected, the autochromes shot in Europe in the years immediately after the continent's self-immolation tell a different story. The immense impact of the war ensured that its themes would reverberate in Kahn's images long after what the poet Wilfred Owen memorably called the 'shrill demented choirs of wailing shells' had ceased to sing.

As a man of deep pacifist convictions, Kahn wanted to record the peace: since he was aspiring to create the most significant chronicle of his own era, he could hardly ignore the aftermath of the event that had most profoundly defined it. As well as the more explicit manifestations of its material effects – such as the apocalyptic landscapes and colossal cemeteries – Kahn's cameramen and *autochromistes* searched for the more subtle articulations of the sundry legacies of the conflict. In some images, the consequences of the war are suggested by what is absent from the picture rather than by what appears in it. In their 1920 film shot at the popular Magic City ballroom on the rue de l'Université in the 7th *arrondissement*, women waltz for Kahn's cameras – often (because of the shortage of men) with each other. The footage is a powerful reminder of a generation of potential husbands lost to the prior claims of Verdun and Ypres.

Other films and autochromes shot by Kahn's team in the years after 1918 show that, despite the Armistice, all certainly was not quiet on Europe's western frontier. Indeed, some of the images shot in Germany record events that come close to making the prefix in the term 'post-war' surplus to requirements. By 1923, chronic economic mismanagement by the leaders of Germany's Weimar republican government had added to the national disaster of military defeat the supplementary calamity of socio-economic meltdown. Early in the year, Germany had experienced a general strike; an invasion by the French army (which marched into the vital industrial region of the Ruhr after Germany defaulted on its war reparations); food riots; and, famously, the onset of the hyperinflation that annihilated the value of the German currency (for example, in January that year, 18,000 German marks were needed to buy a US dollar; by November over 4 trillion marks were required).

As the historian Niall Ferguson has pointed out, the currency collapse eroded the traditional desire for *Ruhe und Ordnung* – peace and order – among the German people. In 1923, when one of Albert Kahn's most intriguing *opérateurs*, Frédéric Gadmer (1878–1954) took his cameras to the Rhineland, the fortunes of Weimar Germany were at their nadir. Each year since the end of the war, the country had experienced at least one attempted coup. Gadmer photographed the aftermath of the most recent abortive insurrection by separatists in the Rhineland town of Krefeld. In addition to his pictures of barricaded

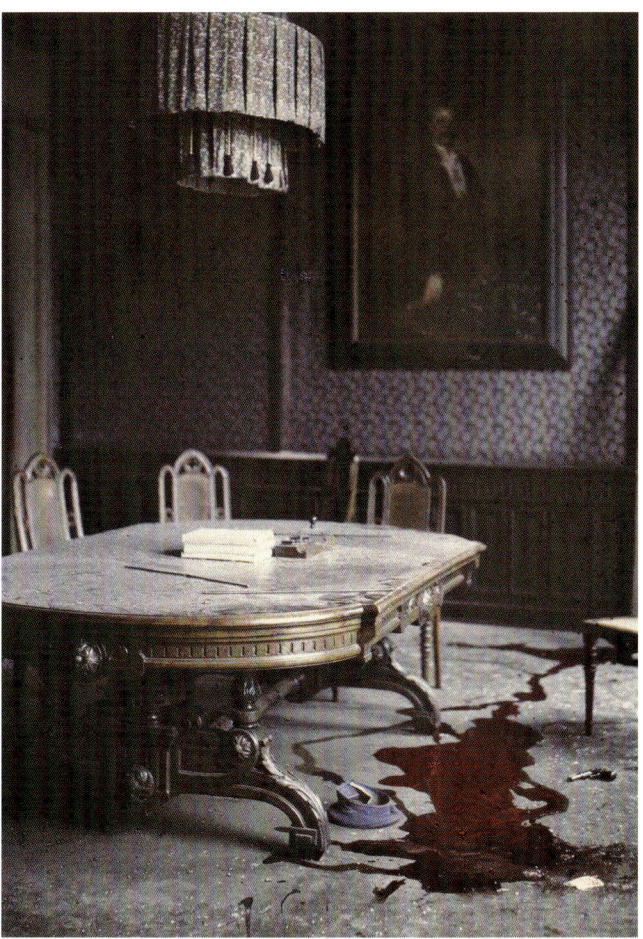

▲ The aftermath of political violence: the blood of a murdered policeman stains the floor of the town hall at Krefeld in the Rhineland on 29 October 1923. The discarded gun can be seen on the right. A40164 Frédéric Gadmer

streets and windows shattered by gunshots, there is a particularly chilling image shot in a room in the town hall where a police officer had been murdered. The victim's body is absent from the picture, but a gun, together with a fat crimson pool of the officer's blood, is visible on the floor.

Although they had to contend with fewer political and economic woes than Germany would suffer, France and Britain were not immune from the post-war malaise. During the General Strike of 1926, the British government set up a militia of special constables to maintain order in response to the perceived new threat of trade union militancy. As the Prime Minister, Stanley Baldwin, saw it, the strike was 'a challenge to parliament and the road to anarchy and ruin'.

But in some places, Kahn's *opérateurs* would also witness a gradual return to the calmer ambience of pre-war life, as Europe's collective anger and grief finally yielded to a desire to forget the catastrophes of the recent past. In Paris, the Archives of the Planet captured on film something of the changing mood at the chic seaside resort of Deauville, where affluent Parisians thronged the beaches and pretty girls twirled their parasols on the promenades.

In these post-war images, it is possible to discern evidence of a new optimism trickling through Europe. In the 1920s, the delusion that the continent had just experienced 'the war to end all wars' encouraged the secondary fantasy that the deal signed at Versailles had rendered further conflict in Europe inconceivable. A few were not so sure: the French marshal Ferdinand Foch said of the Versailles treaty: 'This is not a peace. It is an armistice for twenty years.' Not Kahn, nor his *opérateurs*, nor those who appeared in his autochromes could know how eerily prophetic Foch's words would be.

Paris, France 24 June 1914
Members of a Parisian family sit outside their home in the rue du Pot de Fer, in the Latin Quarter. In the spring of 1928, the British writer George Orwell moved into an apartment on this street, which lies just off the lively and colourful rue Mouffetard. Orwell wrote about his time as a *plongeur* (dishwasher) at a nearby restaurant in his semi-autobiographical novel *Down and Out in Paris and London*, first published in 1933. A7419 Stéphane Passet

Paris, France November 1912
In this autochrome Auguste Léon frames the Palais de la Trocadéro within the arches of that quintessential Parisian landmark, the Eiffel Tower. This image would be impossible to reproduce today: the Trocadéro's original 'Moorish' edifice, which was built for the World Fair of 1878, was demolished and replaced by the Palais de Chaillot in 1937.
A170 Auguste Léon

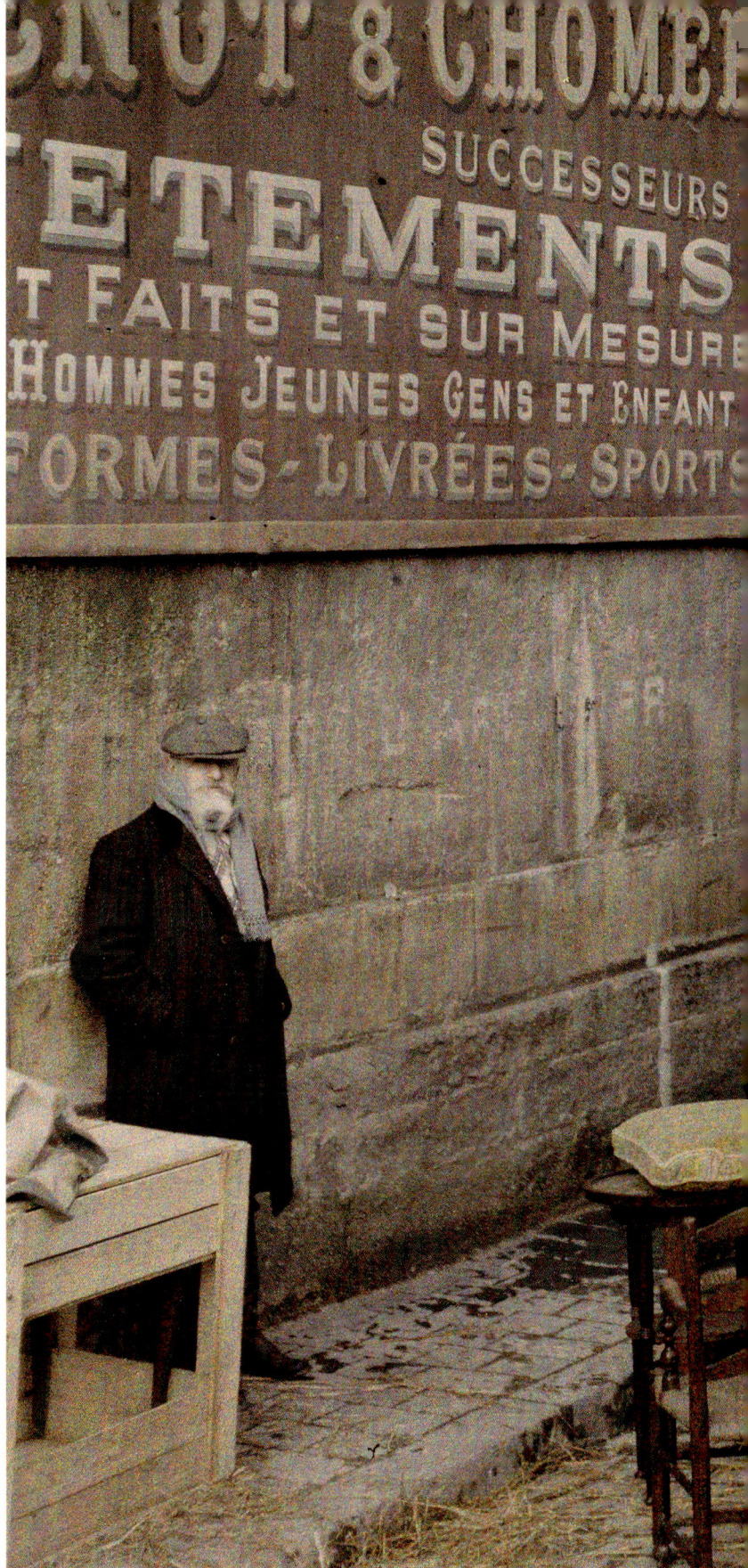

Reims, France 23 March 1917
These men are moving furniture either into or more likely out of a building on the rue de l'Université in Reims. Following a wave of shelling in 1914–15, many buildings in this thoroughfare were destroyed: during the war thousands of postcards were distributed to show the appalling destruction visited upon this street. A11427 Paul Castelnau

The Dordogne, France 6 May 1916
This woman is walking her mule through the village of Les Eyzies-de-Tayac in the *département* of the Dordogne. In the mid-nineteenth century, five skeletons were discovered in a rock shelter at the base of a nearby hill called Cro-Magnon. The place subsequently gave its name to the Cro-Magnon lineage of prehistoric man. A8480 Georges Chevalier

The Dordogne, France 4 June 1916
Midway through the First World War, families all over France were learning to do without fathers, absent – or lost – at the front. For Madame Valade and her children, this meant toiling to cultivate crops, *sans père*, on land near their home village of Thonac in the Dordogne. A8908 Georges Chevalier

Burgundy, France 25 September 1918
A certain Monsieur Louis is working in a vineyard at Saint-Gengoux-le-National in Burgundy. During the war, French troops were dissatisfied with their rations, and this, among other grievances, prompted the widespread mutinies of 1917. Eventually, new commander-in-chief Philippe Pétain boosted morale by securing better-quality food and wine. By the time of this harvest, wine-growing was an important part of the French war effort. A14899 Auguste Léon

Gironde, France October 1920

This group of *vendangeurs*, or grape-pickers, have been stripping the vines in the *département* of Gironde, in southwest France. They are probably working at Saint-Émilion, one of the areas that produce the fine red wines of Bordeaux.

A27304 Fernand Cuville

Reims, France 6 April 1917
Restaurateurs Monsieur and Madame Gauthier guard the entrance to their establishment in Reims. By 1917, most of the people who remained in the city were either those with nowhere else to go, or those with something to protect. The Gauthiers probably fell into the latter category: had they left, their premises might have been looted.

A11561 Paul Castelnau

Thann, France 9 June 1917
During the war, the French managed to wrest control of a sliver of southwestern Alsace from Germany. This woman was photographed in the traditional style of dress worn near Thann, which was retaken by the French in December 1914. Following the region's liberation from the Germans, this costume became a romantic symbol of Alsatian womanhood. A12023 Paul Castelnau

Roscoff, France 6 April 1920

These fishermen were based at Roscoff in Brittany. In the 1970s the port became an important deep-water sea terminal, with regular ferry services linking France to Britain and Ireland. These young men could not have guessed that their grandchildren would see their local economy become more dependent on the spending of 'booze-cruisers' than the landing of cod.

A20840 Georges Chevalier

ROUANEZ AR MOR

Concarneau, France *c.* July 1929
Concarneau in Brittany was, and remains, one of the largest fishing ports in France. Today, however, the recreational yachtsmen in the harbour far outnumber the tuna fishermen. When this autochrome was taken, the boatmen used distinctive blue nets, a tradition that is still celebrated every August in the town's annual Fête des Filets Bleus.
A60447 Roger Dumas

Strasbourg, France 8 December 1918
Taken in the village of Geispolsheim, a few miles southwest of Strasbourg, this autochrome offers a rare glimpse inside an agricultural building. As in so many of the pictures taken by Kahn's photographers in rural areas of France in the months after the First World War, the father of the family is conspicuously absent. A15231-AT Georges Chevalier

Esnandes, France c. 1921

Near Esnandes in the *département* of Charente-Maritime these fishermen, known as *bouchoteurs*, are gathering mussels from the muddy shore. Behind them are the wooden stakes that were wound with ropes, driven into the sand and covered with a protective mesh to provide an appropriate surface for the young mussels to grow upon.

A24820 Fernand Cuville

The Claddagh, Ireland 25 May 1913

These cottages were typical of the homes that Kahn's photographer Marguerite Mespoulet and her travelling companion Madeleine Mignon found in the Claddagh, near the city of Galway on the west coast of Ireland. In her diary Mespoulet wrote: 'There is hardly a village where you don't find several mournful skeletons of grey houses taken over by nettles.' She was 'struck by the misery and filth of the Claddagh's inhabitants', observing that 'the children are never cleaner than the poor ones we see here, infected with ringworm.' In the 1930s these cottages were demolished to make way for a housing estate. A3636 Marguerite Mespoulet

The Claddagh, Ireland 25 May 1913
Wearing the distinctive crimson garments that were favoured by the women of the Claddagh is fourteen-year-old Mian Kelly. Mespoulet's diary claims that local people considered Mian a perfect example of the 'Irish colleen'. One of her surviving relatives affectionately remembers her as 'a fine lump of a woman'. Mian died in 1973, aged seventy-five.

A3640 Marguerite Mespoulet

The Claddagh, Ireland 26 May 1913
The fish being gutted by these two fish-sellers were probably destined for sale in Galway's fish market. In 1913 fishing was so important to the local economy that a local by-law forbade people from keeping gardens, a measure designed to ensure they would spend as much time as possible catching fish.

A3643 Marguerite Mespoulet

Ross, Ireland 29 May 1913
These passengers are riding on board a carriage known as an 'outside car' or 'jaunting car'. Its distinctive design feature is the positioning of the seats, which run parallel to the cart-wheels. This mode of transport was popular for more than a century, but was rarely found anywhere else – and in Ireland it has all but disappeared.

A3660 Marguerite Mespoulet

Connemara, Ireland 31 May 1913
Peat has been cut from Ireland's bogs for more than a thousand years. By the time Mespoulet encountered this peat digger in Connemara, it was Ireland's most important fuel for domestic heating and cooking. Today manual digging has all but vanished; almost all Irish peat is cut using tractor-drawn turf-cutting machines. A3665 Marguerite Mespoulet

Connemara, Ireland 29 May 1913
This view of the archetypal Irish peat digger captivated Mespoulet. In her diary she mused, 'He works alone, under the sky, his feet in water, with just the birds and the clouds for company. It's easy to understand how these people have such vivid and passionate imaginations, and were able to construct the most beautiful legends in the whole of Europe.'
A3653 Marguerite Mespoulet

Galway, Ireland 29 May 1913
In a scene all but impossible to find in the major cities of Ireland today, farmers drive their livestock through the streets of Galway to the annual May cattle fair. A century ago, farming was a vital sector of the economic life of the west of Ireland. Today only about 1 per cent of Galway's population is employed in agriculture and mining. A3650 Marguerite Mespoulet

Galway, Ireland 31 May 1913
This touching image of a ragged-trousered father and barefoot son set against the bleak skies and stony ground of Galway is a study of the hardship endured by Ireland's rural poor. Lives were imperilled by disease as well as poverty: an outbreak of typhoid had affected several communities during Mespoulet's visit. A3667 Marguerite Mespoulet

County Louth, Ireland June 1913
These wheelwrights, from County Louth on Ireland's northeast coast, have coated their cart-wheels and cottage doors with red lead paint, which was then widely used to prevent wood rot. When she took this autochrome Mespoulet was also struggling against the forces of nature: fierce winds compelled her to brace her tripod with her feet to stop her camera from blowing away. A3691 Marguerite Mespoulet

County Meath, Ireland June 1913
Mespoulet and Mignon encountered fishermen in County Meath who were still using traditional coracle-like boats known as *currachs* or *curraghs* on the River Boyne. Made from hazel branches and cowhide, the use of these boats was already in decline. According to Mespoulet, there were just four *currachs* left in the east of Ireland. A3708 Marguerite Mespoulet

Cornwall, England August 1913
In several of his Cornish autochromes, Léon's camera catches local people in front of dilapidated cottages. Despite the growing tourist industry in this area, Cornwall was – and remains to this day – one of the poorest counties in the United Kingdom.

A2356 Auguste Léon

St Ives, England August 1913
Kahn's English residence was an elegant villa overlooking Carbis Bay, but many of his neighbours in St Ives lived in less luxurious accommodation. The port's once-plentiful pilchard stocks had declined, causing hardship for many families. Many children went barefoot, and houses here in the Digey area became dilapidated. Today it is very different: these houses are now sought after as holiday homes, often selling for half a million pounds. A2423 Auguste Léon

Oxford, England May 1924
With the Great Tower of Magdalen College rising in the background, these young people are punting down the River Cherwell in Oxford. Punting was once a pursuit undertaken by those who wished to exploit the river as a source of food, particularly fish and wildfowl. Today it is largely a recreational activity confined to the rivers running through the great university towns of Oxford and Cambridge.

A42814 Roger Dumas

London, England 3 September 1913
A street-sweeper has done a very thorough job in this immaculately tidy residential street. This is one of the few autochromes shot by Léon in London that does not feature a famous landmark. It is possible that the house in the centre of the picture was home to one of Kahn's friends, or a British recipient of one of his travel grants. A2465 Auguste Léon

London, England June 1924
When this autochrome was taken, Fleet Street was still synonymous with the press, and its great newspapers were led by larger-than-life figures, such as Viscount Rothermere at the *Daily Mail* and Lord Beaverbrook at the *Daily Express*. No longer: although some publishers and press agencies remain, not a single national newspaper is now based on the thoroughfare that even journalists themselves call 'The Street of Shame'. A43227 Roger Dumas

London, England June 1924
Now lined with smart apartments and gleaming office buildings, the banks of the Thames in 1924 were flanked by commercial docks and heavy industry. From this stretch of the river, raw materials and manufactured goods were still transported to and from the furthest reaches of the British Empire. Taken from the old London Bridge, this view looks east towards Tower Bridge. A43272 Roger Dumas

Jotunheim Mountains, Norway 12 August 1910
Léon stopped at this little village en route to the Jotunheim, the highest mountain range in Scandinavia. These peaks were mentioned in the Norse sagas, but it was not until the nineteenth century that they were properly explored. Today the area is extremely popular with tourists, who visit to hike and take in the splendour of the mountain landscape. A291 Auguste Léon

Stalheim, Norway *c.* 14 August 1910
These women were employees of the hotel where Kahn and Léon stayed at Stalheim, in the fjord region of western Norway. To get there the travellers would almost certainly have negotiated their car up the one-in-five gradient of the Stalheimskleiva, one of Europe's steepest roads, which boasts thirteen hairpin bends. A317 Auguste Léon

Oppheim, Norway 14 August 1910
This elegant church lies between the villages of Oppheim and Stalheim, around 50 miles from Bergen. In the nineteenth century the established Evangelical Lutheran Christian Church dominated the religious life of Norway. Today, almost ninety per cent of Norwegians are members of the church.
A320 Auguste Léon

▶ **Älvkarleby, Sweden** 25 August 1910
These women in folk costume hail from the municipality of Älvkarleby, around 95 miles north of Stockholm. On the right stands a woman in a style of dress associated with Lapland. There the indigenous Sami people traditionally wore functional fur clothes to combat the Arctic climate, but women adopted more colourful dress styles in the nineteenth century, when affordable dyes became readily available.
A377 Auguste Léon

Stockholm, Sweden 23 August 1910
This remarkable image of Stockholm – surely one of the earliest colour photographs of the city – was taken from the Katarinahissen lift, which offers views across the old town. Léon's autochrome shows the five church spires that rise above the skyline. On the far left is the Riddarholmskyrkan, where Sweden's monarchs are buried; while third from the right is the bell tower of the 700-year-old cathedral, the Storkyrkan. A347 Auguste Léon

Dalarna, Sweden 27 August 1910
Léon saw these villagers picking blueberries in the forest between the towns of Rättvik and Mora in Dalarna province. To this day the people of the area harvest these fruits to make blueberry soup. This local speciality is often served to participants during the gruelling Vasaloppet cross-country skiing race – the largest event of its kind in the world. Held annually in March, more than 15,000 competitors take on its gruelling 56-mile course. A401 Auguste Léon

◀ **Leksand, Sweden** 28 August 1910
In one of the few interior portraits shot by Kahn's *autochromistes* on location, these newlyweds pose before Léon's camera at a photographer's studio near Leksand in Dalarna. The husband is looking very dapper, but it is the extravagantly garlanded bodice of his wife's dress that draws the eye. Appropriately, they are sitting on a lovers' bench in which heart-shaped holes have been cut into the wood.
A417 (detail) Auguste Léon

Rättvik, Sweden 28 August 1910
Auguste Léon found these youngsters wearing their Sunday best in the town of Rättvik in Dalarna. Here boys wore eighteenth-century-style breeches, often coloured yellow or cream. The maiden is wearing a traditional cap and striped pinafore, a costume that distinguished the women of Rättvik from those of nearby Leksand, who often wore dresses in vivid yellow complemented with flowered headscarfs. A416 Auguste Léon

Volendam, Holland 29 August 1929
This fisherwoman and her partner hail from the small port of Volendam, near Edam. In the 1920s many Volendammers would have fished at Holland's largest freshwater lake, the IJsselmeer, but in recent times commercial fishing has declined, and the town's economy relies more on tourists than fish.
A61894 Stéphane Passet

▶ **The Hague, Holland** 25 August 1929
A flower-seller offers his blooms at Scheveningen in The Hague. Although Holland was no longer suffering from the 'tulip mania' of the seventeenth century – when rare bulbs could cost more than a house – flower production remained a lucrative business. Today the country is the world's biggest producer of cut flowers, generating exports worth an astonishing 5.5 billion euros in 2007.
A71351X (detail) Stéphane Passet

Venice, Italy October 1912
Behind this knot of children in the Campo Bandiera e Moro in Venice is the fourteenth-century Palazzo Gritti. By 1912, it had been converted into a hotel. In subsequent years, it would welcome Ernest Hemingway and several members of the British royal family as its guests. A4010 Auguste Léon

Verona, Italy 16 May 1918
Shot in very low light in the vault of the church of San Zeno de Maggiore in Verona, this plate required an exposure time of over a minute to register its subject. Yet by stretching the autochrome's capabilities (and the powers of endurance of this little girl) Cuville produced a chiaroscuro representation of quiet childhood reflection – and one of the Kahn collection's most enchanting images.
A71243 Fernand Cuville

Selva, Italy 25 August 1921
This mode of dress, with its Elizabethan-style sleeves and beehive-like *hennin* hat, was typically worn by women in the Austrian Tyrol. Before the First World War the town of Selva was part of Austria, but in 1918 Italy annexed this territory – a disconcerting event for 90 per cent of the population, who were ethnic Germans. A28679 Frédéric Gadmer

Vicenza, Italy 10 June 1918
Fernand Cuville met this young woman at Vicenza, in the Veneto region. In common with most Italian cities, during the First World War, Vicenza experienced little of the devastation visited on comparable towns in France. Consequently, Vicenza's most important buildings – including architectural masterworks by Andrea Palladio – survived the war intact.
A19398 Fernand Cuville

Siena, Italy 22 September 1913
The 335-foot Torre del Mangia pierces the skies above Il Campo, the main square in Siena, where the famous Palio di Siena horse race is staged. Although it has been run for over 350 years, the contest is very dangerous (for horses and riders), which makes it a controversial event. However, that seldom deters the thousands of spectators who attend this dramatic spectacle. A2570 Auguste Léon

Bilbao, Spain 29 May 1917
Taken from the east, this landscape shows the great industrial city of Bilbao. The vineyard in the foreground lies close to the famous Rioja wine-growing region, which borders the Basque Country. Wine production had been boosted at the end of the nineteenth century when French vineyards were devastated by infestations of deadly phylloxera insects, and merchants from Bordeaux sought new suppliers in Spain. A10948 Georges Chevalier

Bilbao, Spain 29 May 1917
These friends hail from Bilbao, in the region its people call Euskal Herria, otherwise known as the Basque Country. When they were growing up, Basque nationalism was burgeoning: a new political movement, the Euzko Alderdi Jeltzalea (EAJ), was established in 1895 to campaign for Basque independence. Today it is the region's most powerful party. A10963 Georges Chevalier

Granada, Spain 30 June 1914
This gypsy dancer puts on a flamboyant display at Granada in Andalucia. The gypsies of southern Spain were the originators of flamenco dancing: in Granada they often performed at *zambras* (shindigs) in their cave dwellings on the hillside of Sacromonte. Sadly, most of the caves were abandoned after freak flooding in 1962. Since then, many have been restored and are now venues for flamenco cabarets. A4532 Auguste Léon

Sarnen, Switzerland 24 April 1921
This parade, which is taking place at Sarnen, southwest of Lucerne, features men wearing a style of costume that dates from the period when Switzerland achieved independence from Habsburg Germany in 1291. Sarnen holds the oldest surviving chronicle describing the Swiss liberation – a text that is the main source for the legend of the hero William Tell. A26674 Frédéric Gadmer

Lucerne, Switzerland September 1911
Presumably taken from a position on its well-preserved defensive walls, this is a view of the city of Lucerne in central Switzerland. Flowing through the town is one of Switzerland's biggest rivers, the Reuss, which issues from Lake Lucerne (seen here in the background).
A5978 Auguste Léon

The Ruhr, Germany 14 May 1921
In the seventy years before Gadmer captured this engrossing industrial scene, the population of the Ruhr had risen almost tenfold. As this densely-packed landscape of chimneys testifies, rapid industrialisation had transformed the region. Served by an extensive network of canals, the Ruhr had become the engine-room of the German economy.
A26912 Frédéric Gadmer

The Ruhr, Germany 23 October 1923
This is probably the Victor Ickern coking plant in Castrop-Rauxel near Gelsenkirchen, one of many factories built to exploit what was one of the biggest coalfields in the world. In 1923, after French forces occupied the region in reprisal for Germany's failure to pay its war reparations, workers organised a programme of passive resistance that brought almost all industrial production to a halt.

A40099 Frédéric Gadmer

Oberfelden, Germany 18 August 1912
These villagers are caught on camera against the backdrop of a generously proportioned half-timbered cottage in Oberfelden, around 25 miles west of Nuremberg. The methods used to build this type of traditional vernacular architecture were deployed in many parts of northern Europe, including France, Denmark and Britain, but similar techniques were also used earlier elsewhere in the world, notably in ancient Japan. A4128 Auguste Léon

2 The Americas

On Friday, 13 November 1908, Albert Kahn's chauffeur, Alfred Dutertre, was worried. Somewhere between the St Lazare railway station in Paris and the terminus at Cherbourg – where he was about to embark on his first-ever journey across the Atlantic – couriers had misplaced his luggage. Inside was some very important and expensive equipment. But, happily, he was reunited with his bags before ten o'clock that evening, when the steamship *Amerika* slipped out across the waters of *La Manche* and headed west for New York.

A month earlier, Kahn had given Dutertre the exciting news that he would be accompanying his employer on a voyage around the world. In the intervening weeks, he had made extensive preparations for his journey. In mid-October, Kahn had asked him to buy a Pathé film camera, plus 3000 metres of ciné film; and a Verascope Richard stills camera, together with four thousand glass photographic plates. Most were black and white, but Dutertre had also acquired examples of the Lumière brothers' latest technology: several hundred colour autochromes.

Kahn had also sent his twenty-three-year-old chauffeur for lessons in camerawork at the famous cinema company Pathé. In August and September Dutertre practised with Kahn's cameras by taking pictures in and around Paris.

▲ Migrants crowd the lower decks of the SS *Amerika* en route to New York in November 1908. N126 Alfred Dutertre

◀ With her deerskin gloves and Tom Mix-style hat, this Canadian cowgirl attends to her Appaloosa horse at a ranch near Calgary in May 1926. A49074 (detail) Frédéric Gadmer

During the eight-day passage aboard the *Amerika*, Dutertre put his training to good use. He photographed passengers playing deck games and on-board musicians entertaining travellers at their morning concerts. Dutertre also tried to capture the sounds aboard the ship on Kahn's gramophone recording machine, but his efforts were fruitless: because of the Atlantic's rough November waves, according to his diary, 'the needle moved brutally on the wax'.

▲ Dutertre took numerous black-and-white photographs in New York, including one of Manhattan's first skyscraper, the 21-storey Flatiron Building, which was built in 1902. N161

On Saturday, 21 November the *Amerika* docked in New York. After officials had subjected them to a quarantine inspection and searched their luggage, Kahn and Dutertre checked into the St Regis Hotel on Manhattan's Fifth Avenue. For the next three days, Dutertre would take his camera on to the streets of North America's most exciting city.

Just six weeks before their arrival, on 27 September 1908, the first-ever Model T had rolled off Henry Ford's production line in Detroit. As Dutertre's pictures show, the motor car had by then made only a marginal impact on New York. As well as shooting a series of views of New York's most famous landmarks – Brooklyn Bridge, Broadway, Central Park, Wall Street – Dutertre produced several more dynamic pictures (mostly in black and white) that capture the energy that remains so characteristic of the city's street life. Evidently, he was fascinated by New York's architecture – in particular, the imposing towers that were rising into the skies above Manhattan.

Just before 9 p.m. on Thursday, 26 November, the travellers boarded an express train upstate to Buffalo. From there they took a car and headed for Niagara Falls. Kahn and Dutertre crossed over the border to Canada, which they thought afforded the best view. Dutertre's autochromes of the Falls are among the earliest-known true-colour pictures of one of the great natural wonders of North America.

The two Frenchmen reached the next stop on their itinerary, Chicago, on Thanksgiving Day. Curious to see the pictures they had taken, they had hoped to develop some of their negatives, but the requisite supplies were unavailable because the shops had closed for the holiday. This must have been particularly disappointing for them, because a year earlier the world's largest department store had opened in the city. Famed for its glorious ceiling, created by the designer Jacob Holzer of Tiffany's and constructed out of 1.2 million pieces of iridescent glass, the twelve-storey Marshall Field building on State Street would become an iconic example of North American commercial architecture. Instead, Kahn and Dutertre had to settle for a glimpse of a somewhat more prosaic aspect of Chicago's commercial life – a tour of the city's slaughterhouses, an industry described in Upton Sinclair's novel *The Jungle* just two years earlier.

▲ Throughout the journey Dutertre took advantage of railroad stops to capture some of the earliest-known colour photographs of buildings in the American prairies. D4137

Then they boarded their next train, heading west through Illinois and Iowa towards the city of Omaha. From an observation deck at the rear, Dutertre trained his film camera on the snow-whitened prairies. Yet he took few autochromes during this part of the journey; conceivably, he might have considered it wasteful to use expensive colour plates to photograph such an etiolated landscape. The travellers arrived in Omaha on 27 November, Dutertre's twenty-fourth birthday, and from there moved on to California. In his diary, Dutertre reports that on 28 November the outside temperature was 15 degrees below zero and the countryside was blanketed with snow. Such is the climatic diversity of the United States that his diary entry for the following day reads:

Sunday, 29 November. No trace of snow, but we are crossing a desert, no vegetation, no sign of life. At about 2 o'clock the snow reappears; we started to climb up the Sierra Nevada. The railway line is on the side of the mountain. To protect it from avalanches it is covered for many kilometres by tunnels and boards. Superb views. Then we started our descent towards the west of the Sierra; a rapid change, the snow disappeared and we saw the first signs of habitation; the first cultivated olive trees, palm trees, vines etc. We passed through Sacramento and arrived at San Francisco at 9 o'clock. We went to the Fairmont Hotel, a superb building, rebuilt after it burned down in the fire resulting from the earthquake that destroyed San Francisco on 18 April 1906,.

Few of Dutertre's autochromes of San Francisco have survived, but those that have represent a rare true-colour photographic record of the aftermath of one of North America's worst-ever natural disasters. As his pictures show, more than two years on the city had still not rebuilt itself after a calamity that had killed at least three thousand people and reduced more than 80 per cent of the city's buildings to rubble. In one district, the US army had built more than five and a half thousand makeshift houses, where up to twenty thousand refugees had lived. By November 1908 many had found new homes, but there was still an enormous amount of reconstruction work to do: even the City Hall remained in ruins. The earthquake would have a momentous effect on California: it would topple San Francisco from its position as

▲ An advertising hoarding appears to have survived the earthquake that devastated San Francisco in 1906 – unlike the buildings that once surrounded it. D4128 Alfred Dutertre

the pre-eminent cultural centre and commercial port on the US Pacific coast, as businesses and people shifted their investments and themselves south to the city's main metropolitan rival, Los Angeles.

On 1 December, Kahn and Dutertre left the stricken city after boarding the 13,000-ton steamship *Mongolia*. Their ship's ultimate destination was the Japanese port of Yokohama, but most passengers (the ones travelling first class, at least) were planning to disembark at its first port of call: Honolulu, the capital city of the Hawaiian island of Oahu.

At the end of the nineteenth century, following a combination of internal political wrangles and some barely disguised imperialistic manoeuvres by the United States, Hawaii's traditional monarchy had been destabilised. In 1893, after an alliance of American and European plantation owners had attempted a *coup d'état*, Hawaii's Queen Liliuokalani relinquished her authority. Within five years the United States government had officially annexed Hawaii, which became a US overseas territory in 1900. It is likely that many of Kahn's American fellow passengers were among the first to be lured to Hawaii by a protracted series of promotional lectures given in San Francisco by the businessman and promoter W. C. Weedon in 1902. His vivid descriptions of 'those remarkable people and the beautiful lands of Hawaii' persuaded around two thousand travellers to visit the islands every year.

As the *Mongolia* docked, Dutertre watched young Hawaiians diving for coins that had been cast into the waters by the passengers. The *Mongolia*'s stopover was brief: the Frenchmen had just nineteen hours to explore the island. They hired a car and managed to squeeze in visits to a few of Hawaii's main attractions – a former royal palace, the aquarium, the Japanese quarter, markets, volcanic landscapes and Honolulu's famous Waikiki beach. With time so short, it appears that Dutertre decided not to expend his supply of autochrome plates here: indeed, only a few of his Hawaiian pictures, all black and white, survive.

By 10 a.m. on 2 December, Kahn and Dutertre had rejoined the *Mongolia* for the onward journey to Japan. A further three months travelling lay ahead of them before they would complete their

circumnavigation of the globe and return to their beloved France.

But Albert Kahn's interest in the life and culture of the Americas had not abated. In August, only five months after completing his *autour du monde,* he made another Atlantic crossing. This time he headed south – to Brazil, Argentina and Uruguay – and he had decided to leave Dutertre, his faithful Passepartout, at home. The identity of the photographer who replaced Dutertre on this journey remains uncertain, though there is strong circumstantial evidence to suggest that Kahn was accompanied by the first full-time professional photographer he had recruited for his Archives of the Planet.

A former postcard photographer from Bordeaux, Auguste Léon joined Kahn's embryonic project in June 1909. During that summer he shot his first images for Kahn in the *département* of Puy-de-Dôme in central France. Although it is not absolutely certain, all indications suggest that Léon accompanied Kahn aboard the SS *König Friedrich* as it steamed across the Atlantic: not only was he the only professional photographer employed by Kahn at this time, but he seems to be present in a photograph that was taken on board the ship during the crossing (right).

Little is known about Kahn's *voyage Amérique Latine*, but the pictures taken during the journey suggest that his primary interest lay in Brazil.

▶ A man strongly resembling Auguste Léon (on the right) is among the passengers aboard the SS *König Friedrich* en route to South America in 1909. A69596

Although numerous black-and-white stereoscopes were shot in Uruguay and Argentina, only the Brazilian cities of Rio de Janeiro and Petrópolis received the full-colour treatment.

Kahn's autochromes of Rio are among the most surprising in the Archives. These images – which are some of the earliest-known true-colour photographs of one of the world's most scintillatingly colourful cities – present a place that is almost unrecognisable from the pulsating metropolis we know today. In 1909, it was Brazil's capital and its most populous city. Yet in these autochromes, the pavements and thoroughfares are empty: the streets that are today some of

THE AMERICAS

▲ Built on land reclaimed from Guanabara Bay, the new Avenida Beira Mar was free of traffic in August 1909: today it is one of Rio's busiest roads. A69840 probably Auguste Léon

the busiest in Rio are devoid of cars, tourists and even Rio's own citizens – its famous cariocas.

This was the last time that Kahn would join his photographers on a mission to the Americas, but, independently, his *opérateurs* would make further Atlantic crossings in the years ahead. In 1922, the Archives of the Planet asked the intrepid and indefatigable cinematographer Lucien Le Saint (1881–1931) to join French fishermen making the 2500-mile journey to the fishing grounds lying off the coast of Newfoundland. Le Saint's films are an intimate, sympathetic and detailed cinematic opus, revealing the brutal working conditions endured by the men of the fleet. They are reminiscent of the lives of the Breton fishermen described in Pierre Loti's 1886 novel *Pêcheur d'Islande*, and bear comparison with the much more famous documentary film *Nanook of the North*, which was also released in 1922, by the pioneering American film-maker Robert Flaherty.

Le Saint was a specialist cinematographer, and during this expedition he shot no autochromes. But four years later Kahn did add new colour images of North America to his collection when, in March 1926, Jean Brunhes and Frédéric Gadmer embarked on a three-month journey across Canada.

After visiting Montreal, Niagara, Winnipeg and Regina, on 6 May the travellers reached the evocatively named town of Moose Jaw in Saskatchewan. Today the city is a model of provincial propriety; but in 1926 – the middle of the Prohibition era in the USA – it was a notorious hub for cross-border smugglers of bootleg booze. The gangster Al Capone is believed to have been a regular visitor to the city; it is suspected that he had stakes in several of the brothels and gambling joints that lined River Street, which Gadmer photographed on the day he arrived.

Moose Jaw's underground economy had a physical manifestation as well. In the 1980s, an extensive network of subterranean tunnels was discovered under the city centre. It is presumed that the tunnels were used by mobsters in the 1920s, although their

actual construction pre-dates the Prohibition era: they were built in the early years of the nineteenth century by heating engineers as a means of aiding the distribution of fuel in winter, when outside temperatures in Moose Jaw could dip to minus 40°C. By the time Gadmer trained his lens on the city's streets, the tunnels below had become home to large communities of Chinese migrant workers. Many lived below ground in an attempt to avoid the pernicious 'head tax' that was being imposed on them by a Canadian government determined to discourage immigration from Asia.

▲ The Brunswick Hotel (left) in River Street West, Moose Jaw, was allegedly an entry point to the tunnels used for gambling and bootlegging. A48933 Frédéric Gadmer (May 1926)

On 9 May Gadmer and Brunhes arrived at their next stop, Calgary. A large new oilfield had been discovered in nearby Turner Valley the previous year, and the find was already transforming Calgary's economic fortunes. But the French travellers appear to have been at least as intrigued by local cultural traditions as by contemporary change. For a particularly quaint series of autochromes, cowboys and cowgirls pose in their decorated leather waistcoats, chaps and gloves at the Rocky Ranch near by.

After further excursions to Edmonton and Vancouver, the travellers turned east for a final stopover in Banff. There, as elsewhere during their Canadian odyssey, Gadmer was primarily concerned with close observation of the Canadian landscape. Although the human impact on the physical geography of Canada is represented in these autochromes – there are several striking townscapes, as well as some intriguing pictorial traces of traditional and modern Canadian culture – by and large Gadmer's North American portfolio contains relatively few images of dynamic human activity. Instead, in Gadmer's work, priority is given to the vast landscapes of the Great White North. The true stars of his Canadian show are the imperious mountains, the virgin pines, the vitreous lakes and the exquisite, crystalline snow. The human presence has been marginalised in these pictures; what Gadmer delivers instead is a photographic homage to the epic grandeur and pristine majesty of the Canadian wilderness.

◀ **New York, USA** November 1908
When it opened a year before Dutertre shot this autochrome, New York's 19-storey chateau-style Plaza Hotel towered over buildings near the corner of Central Park South and Fifth Avenue. After a century of relentless development, it is today dwarfed by midtown Manhattan's skyscrapers. It remains one of only two New York hotels to be officially designated a National Historic Landmark. D4033 Alfred Dutertre

Niagara Falls, USA 25 November 1908
Dutertre's autochrome of Niagara Falls is among the earliest colour photographs of one of North America's great natural wonders. Just three years before this picture was shot, measures were taken to control Niagara's rate of recession, which is caused by fast-moving waters eroding the bedrock. Hitherto, the Falls were moving upstream by around 6 feet every year. D4070 Alfred Dutertre

Vancouver, Canada 22 May 1926
Constructed in 1887 (a year after hundreds of houses were consumed in the city's Great Fire), the august Hotel Vancouver at the corner of Georgia Street and Granville Street conformed to new regulations stipulating that buildings must be made from brick or stone. The hotel would never yield to flame – but it did to developers, who demolished it in the 1930s.
A49169 Frédéric Gadmer

Calgary, Canada 13 May 1926
Gadmer met these cowboys at a ranch near Calgary in Alberta. Renowned for its vast farmlands – the Prince of Wales (the future Edward VIII) owned the 6000-acre E. P. Ranch there – the province provided employment for thousands of cowboys. Although two-thirds of Albertans are now city-dwellers, cowboys still figure prominently in rural areas – and at the annual Calgary Stampede. A49044 Frédéric Gadmer

Vancouver, Canada 23 May 1926
In Vancouver's Stanley Park, Gadmer found three magnificent totem poles. To the left is Chief Wakas' totem, topped with the outstretched wings of the thunderbird; in the centre is Chief Sisa-Kaulas' pole; and on the right, a house post, traditionally used as a roof support. All were crafted by the Kwakwaka'wakw people (formerly known as Kwakiutl), who inhabited Vancouver Island and parts of mainland British Columbia. A49179 Frédéric Gadmer

Lake Louise, Canada 6 June 1926
The spectacular peaks of the Canadian Rockies encircle Lake Louise in the province of Alberta. Lying at an elevation of 5680 feet, the lake is fed by run-off from the Victoria Glacier, which flows down the mountain in the background. Mostly unspoilt, unknown and undeveloped when Gadmer arrived, today the area is one of the premier ski resorts in Canada. A49296 Frédéric Gadmer

Montreal, Canada 11 April 1926
Near Montreal, Gadmer and Brunhes visited one of the city's oldest houses. It was built around 1720 – a time when Montreal was enjoying an early real estate boom, as colonialists parcelled out land to new migrants arriving from France. Many of Montreal's buildings from this period were destroyed in a fire that ravaged the city in May 1765. A48669 Frédéric Gadmer

Montreal, Canada 13 April 1926

Colonel Georges and Madame Pauline Vanier stand beside a German howitzer, one of more than five hundred captured German field guns that were transported back to North America by the Canadian Army as war booty after 1918. A war hero who founded the Royal 22e Régiment (nicknamed 'the Van Doos'), Georges Vanier lost his right leg at Chérisy in France in 1918. He later became a distinguished diplomat, and in 1959 was the first Canadian-born francophone Governor General of Canada. Pauline Vanier, who had served as a nurse during the First World War, devoted much of her life to social causes. During the 1940s both she and her husband campaigned tirelessly for Jewish refugees fleeing from Nazi persecution. In recognition of their humanitarian work, the Vaniers have been nominated for beatification by the Roman Catholic Church.

A48688 Frédéric Gadmer

Petrópolis, Brazil September 1909
In the hills around 40 miles north of Rio de Janeiro lies the 'Imperial City' of Petrópolis – so named because it was the place where Brazil's boy Emperor, Pedro II, built his summer palace in 1845. On the right is the concourse of the city's railway station, but the train service that connected Petrópolis to Rio was discontinued in 1964.

A69853 probably Auguste Léon

Rio de Janeiro, Brazil August 1909

Nestled in the hills behind these people is the suburb of Santa Tereza in Rio de Janeiro. It is possible that the members of this group might be residents of one of Rio's first *favelas* – the hillside shanty-towns that were established by demobilised soldiers who had fought an anti-secessionist war in northern Brazil in 1897. Today around one in six of Rio's total population of just over 6 million people live in the city's *favelas*. Some of the adults in this autochrome might also be emancipated slaves, since Brazil had only abolished the institution in 1888, just twenty-one years before this picture was taken. A69819 probably Auguste Léon

3 The Balkans

In October 1912, Auguste Léon and Jean Brunhes embarked on the project's first mission to the Balkans. They were arriving at a moment when the authority of the Turkish Ottoman Empire – the political entity that sutured the ethnically diverse nations of the Balkans together – was about to break apart. Within the next two years, the First and Second Balkan Wars (of 1912 and 1913 respectively) would see the peoples of Serbia, Bulgaria, Macedonia, Montenegro, Albania, Romania, Greece and Turkey locked in a conflict of shattering brutality. Across the region, nationalists sensed that long-cherished hopes of independence and self-determination might now be realised. Accordingly, huge numbers of men were mobilised. In Bulgaria alone, around half a million men – a quarter of the adult male population – were being readied for war.

But in October 1912, when Léon and Brunhes travelled through Bosnia and Croatia, they did so without a prior (or, at least, explicit) photojournalistic intent. Their purpose was to record distinctive aspects of the geographical and ethnographical make-up of the region. This exercise was a far from straightforward affair. At this point, the Balkans were a *macédoine* – a discombobulated multicultural fruit salad of different nationalities sharing a geographical space.

Most ethnic, national and religious tensions had been kept in check by the overarching authority of the Ottoman Empire that ruled much of the region – albeit remotely, and with a relatively light touch. By 1912, however, that authority had eroded: throughout the Balkans, nationalists now anticipated the fission of Ottoman imperial rule. The Great Powers of Europe were alive to the destabilising potential of the Balkans – and events in Macedonia were foremost among their concerns. Jean Brunhes had asserted: 'It is always in Macedonia that the destinies of the peninsula have been determined.' His point was both timely and perceptive.

Brunhes and Léon left the Balkans that autumn, but returned to the region the following spring. Between April and the end of October 1913, the travellers carried Kahn's cameras into almost all the theatres staging the Balkans drama: Serbia, Macedonia, Turkey, Greece, Albania and Montenegro. Moreover, Léon was not the only photographer working for Kahn in the region at this critical point in its history.

The intrepid *opérateur* Stéphane Passet (1875–c.1943) arrived in the Greek port of Salonika in September 1913 – just three months after the start of the Second Balkan War. Dissatisfied with the treaty

◂ Resplendent in elaborate bridal head-dresses, velvet vests and ravishing lace aprons, these women were photographed on the island of Corfu in 1913. A66626 (detail) Auguste Léon

▲ Members of Macedonia's ethnic Albanian minority photographed on 20 May 1913 in Ohrid, once a Greek possession, and a former royal capital of Bulgaria. A2097 Auguste Léon

The ultimate fate of Greek Macedonia's most important city, the gateway port of Salonika, is depressingly representative of the messy disintegration that was about to befall the entire region. Under Ottoman rule, Salonika – now known as Thessaloniki – was home to substantial communities of Muslims and Greek and Bulgarian-speaking Orthodox Christians. But the largest minority was Jewish. This mostly Sephardic population had settled there after their expulsion from Spain by the 'Catholic Monarchs', Ferdinand and Isabella, during the Inquisition some four centuries earlier.

that had followed the First Balkan War, Greece and Serbia, two of the countries that had been principally responsible for ending Ottoman rule in Europe, formed an alliance against the third – their former ally, Bulgaria. After a series of skirmishes, Bulgarian forces attacked Greek and Serb units stationed in Macedonia. The counter-attack was swift and brutal. In a month-long rampage, supported by Turkish and Romanian troops, the Greeks and Serbs indulged in a blood-sodden cycle of sack, slaughter and atrocity. In Thrace and Macedonia whole communities were eviscerated. Altogether, in just four weeks of fighting, an estimated sixty thousand people were killed.

Not surprisingly, given the extent of the chaos caused by both Balkan Wars, huge numbers of people had taken flight: it has been estimated that around eight hundred thousand people took part in one of the largest population movements in modern European history. With his cameras, Passet entered a refugee camp holding hundreds of the region's four hundred thousand-plus displaced Muslims. His films and autochromes show the miserable fate that had befallen this bedraggled exodus, most of whom had headed for Salonika in the hope of finding safe passage by boat to Turkey. Inevitably, living conditions in the camp were so insanitary that they bordered

on the deadly. In a letter to Jean Brunhes, Passet observed: 'These unfortunates are without possessions and at this time of year, when the earth is parched by the sun, they can no longer find food. Cholera is rife there. The Greek authorities do not seem to realise the gravity of the situation and if serious measures aren't taken, there will be a terrible epidemic.'

Within the next decade, the Muslim migrant population abandoned Salonika. After a further twenty years, the city's Jewish presence would disappear too: at least 90 per cent of its Jewish community was exterminated after the Nazis occupied the city in 1941. Most of those who had been residents of what had once been the most populous Jewish city in the world ended their days not in Greece, but in Auschwitz.

As dreadful as the Balkan Wars were in their own right, the upheaval and carnage they caused simply prefigured even greater displacement and suffering to come. Well before the Nazis implemented their own infernal scheme, Albert Kahn's cameras had already registered the deplorable effects of the massive migrations that followed the 1919–22 war between Greece and Turkey.

At the post-First World War Peace Conference in Paris, Britain – specifically the Prime Minister,

▲ Greek Prime Minister Eleuthérios Venizélos (left) in January 1919, and the Turkish nation-builder Kemal Atatürk in December 1922. A15143 (left) Auguste Léon and A37088 Frédéric Gadmer

David Lloyd George – stated that it would favour (and support) attempts by Greece to use military force to establish itself as the most powerful state in the region. Emboldened by the British promise, the Greek leader Eleuthérios Venizélos took Lloyd George at his word, and Greek forces were dispatched to the main Anatolian coastal port, Smyrna (known today as Izmir). Venizélos did not know it, but he had initiated a catastrophic enterprise that would leave tens of thousands of his countrymen dead, his army routed, the geographical boundaries of his homeland greatly diminished and his own political career in ruins.

The seizure of Smyrna from the Turks in May 1919 was followed by almost two years of fruitless diplomatic vacillation, but eventually the Greek army attacked. Initially the Greek forces scored some notable gains, but soon they found themselves badly overstretched. By the summer of 1922, under the charismatic leadership of Mustafa Kemal Pasha (still better known today as Atatürk), the Turks were in the ascendant.

On 26 August, the Turks attacked. Reduced to a disorderly rabble, the Greek army began their chaotic 400-mile retreat towards Smyrna. Although in disarray, they managed to slow down their pursuers by torching scores of Turkish villages. The Greek tactic was guaranteed to outrage their enemy. But soon Turkish forces would exact a terrible retribution.

For two weeks, Greek and Armenian civilians fleeing the advancing Turkish army had been pouring into Smyrna. Most of the Greek army managed to board ships before Atatürk's men arrived. For the refugees, however, escape was all but impossible. In the days after 9 September, when the Turks took control, a frenzied terror was unleashed on the residents and refugees of Smyrna. Churches were incinerated. Men, women and children were bayoneted in the streets. When Turkish troops sprayed petrol over houses in the city's Armenian quarter, fear turned to panic. Some three hundred thousand people raced to the quayside, desperately seeking passage on ships that might rescue them from what seemed certain death. Moored in the harbour was a huge flotilla, including three American destroyers and two British battleships. But the Great Powers had resolved not to intervene. On board one of the British vessels, the British journalist Ward Price described the scene: 'The sea glows a deep copper-red, and, from the densely packed mob of many thousands of refugees huddled on the narrow quay, between the advancing fiery death behind and the deep water in front, comes continuously such frantic screaming of sheer terror as can be heard miles away.' The sack of Smyrna lasted just six days. In that time, more than a hundred and twenty thousand people perished.

Throughout this horrifying episode, Kahn's photographer Frédéric Gadmer shot films and photographs that detail the impact of the catastrophe on the lives of thousands of ordinary people trapped in the war zone. The catalogue of suffering contains panoramas of the razed remains of Turkish villages. There are vast and winding columns of the dispossessed, desperately searching for a safe passage through a devastated landscape. Sometimes his wide framing can lend his autochromes an air of dispassionate detachment; but when a scene warms Gadmer's sang-froid, he moves in close to reveal the pain, exhaustion and dread of an anguished people.

Neither the human misery – nor the cynicism of the Great Powers – ended there. Following a deal brokered by the British Foreign Secretary, Lord Curzon, at Lausanne in 1923, the Greek and Turkish governments agreed to implement what has become

known as the Great Population Exchange. Eight hundred thousand Greek Christians were compulsorily removed from Turkey; in return, around 1.3 million Turks living in Greece were forcibly resettled in Turkey. The immeasurable distress that inevitably attended such enormous displacements has haunted the collective consciousness of the Balkans ever since. In 1992 Bosnia and 1997 Kosovo we hear the gruesome echo of Anatolia in 1923. These colossal demographic ruptures of the early 1920s were not the first, and would not be the last, instance of 'ethnic cleansing' in this long-suffering region.

Of course, between the events at Salonika and those at Smyrna lay Sarajevo. There, on 28 June 1914, the nineteen-year-old Bosnian Serb student Gavrilo Princip would aim his .38 calibre Browning pistol at Archduke Franz Ferdinand, deflect the course of European history, and ensure that the Balkans would evermore be eyed warily as a place of incendiary instability.

Between October 1921 and his departure from the Balkans the following February, Gadmer shot around 1350 autochromes. Considered alongside the films and pictures amassed in the pre-war missions, they present a detailed visual record of the unravelling of an empire and its reincarnation as a geopolitical complex of modern nation-states. More importantly, they bequeath to us an arrestingly intimate insight into the consequences and costs of the actions of grossly irresponsible politicians and morally derelict soldiers.

The events captured by Gadmer were anathema to a committed pacifist and internationalist like Albert Kahn. He had devoted much of his fortune – indeed, much of his life – to the creation of social, political and cultural projects that promoted peace. The images his *opérateurs* had brought back from the horrifying imbroglio in the Balkans were a bloody reminder of the necessity and urgency of his enterprise.

▼ A landscape of devastation: the aftermath of the sack of Smyrna, seen here in January 1923, four months after Turkish forces took control of the city. A37378 Frédéric Gadmer

Prizren, Serbia 8 May 1913
The River Bistrica courses through Prizren in Kosovo, which the Serbs had taken over in 1912. The scene looks peaceful, though the reality was anything but. In the year this photograph was taken Serbia's army overran Prizren and committed atrocities against its ethnic Albanian majority. An eyewitness said of it: 'This city seems like the kingdom of death.'
A1942 Auguste Léon

Prizren, Serbia 9 May 1913

These Tziganes, or Roma (gypsies), have gathered outside a house at Prizren, in what is now UN-administered Kosovo. Gypsies have been living in the Balkans since the thirteenth century, although by the time this picture was taken, many had exchanged their traditional itinerant lifestyle for a more settled existence in Serbia's towns and cities.

A1957 Auguste Léon

Kruševac, Serbia 29 April 1913
Léon photographed these Muslim women selling ducks and chickens in or near the city of Kruševac in central Serbia. Kruševac, the capital of Serbia in the late fourteenth century, was almost completely destroyed during the Second World War. Since this picture was taken the area's Muslim presence has all but disappeared. A1817 Auguste Léon

Openica, Macedonia 22 May 1913
Women work in a rustic, ramshackle residence at Openica in modern-day Macedonia. At this point Macedonia's political destiny trembled on a knife-edge: the Balkan alliance that had destabilised Ottoman rule in Europe was disintegrating. Within days, these women would be living in a war zone, as the anti-Ottoman alliance shattered and its constituent entities scrambled for a share of Macedonia. A2150 Auguste Léon

Smilevo, Macedonia 17 May 1913
These girls are members of an affluent Serbian family from Smilevo, a town in the district of Bitola in Macedonia. The Serb army's victory at the Battle of Kumanova in October 1912 had wrenched Bitola from the Ottoman grasp. Fighting continued for months, but two weeks after this picture was taken, the Treaty of London ended Ottoman rule in Macedonia for ever.
A2059 Auguste Léon

Mostar, Bosnia 19 October 1912
Built in 1566, the elegant 88-foot-long Old Bridge spanning the Neretva River at Mostar testified to the ingenuity of the Ottoman engineers who constructed it. But in November 1993, at the height of the civil war, Bosnian Croats blew apart the town's most important landmark. Following a $13 million restoration programme, the bridge was rebuilt. It was finally re-opened on 24 July 2004. A1561 Auguste Léon

Sarajevo, Bosnia 15 October 1912
Since Bosnia had been annexed by Austria-Hungary in 1878, its leaders considered it futile to join their neighbours Greece, Bulgaria, Serbia and Montenegro in a war against the Ottomans. Nevertheless, as the faces of the bread-seller and his customers seem to suggest, tension and uncertainty were rife amid the increasingly febrile political atmosphere in the Balkans. A1492 Auguste Léon

Cetinje, Montenegro 23 October 1913
With the handle of his gun protruding conspicuously from his waistband, this is Mayor Vuletic of Cetinje. Vuletic was a distinguished citizen of a town in an area once known as the 'Sparta of Serbia' because of its history of resistance to Ottoman rule. When this picture was taken, Cetinje was Montenegro's capital city, but it would be displaced by Titograd (now known as Podgorica) in 1946. A2933 Auguste Léon

Dubrovnik, Croatia 23 October 1912
Léon and Brunhes encountered these women in the port of Dubrovnik, on Croatia's Dalmatian coast. Known as the 'Pearl of the Adriatic', Dubrovnik suffered immense damage during Croatia's independence struggle in the early 1990s, though some of the city's old cottages have since been restored. A1663 Auguste Léon

Salonika, Greece 14 May 1913
Boatmen prepare to moor at the strategically vital port of Salonika on the coast of the Greek region of Macedonia. This mesmerising image preserves a view of the port that has since vanished: over 9000 buildings were destroyed when fire swept through the city in August 1917. A2014 Auguste Léon

Salonika, Greece 24 May 1913
Stationed at the Greek garrison in Salonika were these soldiers from Crete. Three weeks after Léon shot this autochrome they would be defending Salonika from attacks by the Bulgarian army at the start of the Second Balkan War. But the assault was swiftly repelled – ensuring this strategically vital port remained in Greek hands.

A2178 Auguste Léon

Athens, Greece 9 October 1913

This is one of the earliest colour photographs of the Greek capital. The roof-tops of the uniformly low-rise houses of Athens stretch towards the famous Acropolis, upon which stands that great building of antiquity: the Parthenon. By absorbing neighbouring towns – and the migrants who arrived in the great population exchange of 1923 – the Athens metropolis has seen a tenfold increase in its population since 1913. A2744 Auguste Léon

Mount Athos, Greece 10 September 1913
This disturbing image was taken in the weeks after the Second Balkan War, near the Grand Lavra monastery on Mount Athos. Although at first sight this appears to be an incident of 'ethnic cleansing', it is equally possible that the man under arrest was a bandit. Nevertheless, given the wider historical context, this remains one of the more unsettling autochromes in Kahn's Balkan collection.
A3825 Stéphane Passet

Salonika, Greece 2 September 1913
The Second Balkan War had effectively ended six weeks before Passet met this group of refugees near Salonika. The conflict had displaced thousands of people seeking a place of safety amid widespread reports of violence, atrocity and terror. These people found refuge in Salonika, one of the most ethnically diverse cities in the Balkans. A3853 Stéphane Passet

Melnik, Bulgaria 17 September 1913

In the months following the Second Balkan War, there was a wave of revolts by ethnic Bulgarians, who had suddenly become an 'ethnic minority' in the post-war diplomatic carve-up of the Balkans. Passet encountered this group of refugees who had landed in Melnik, which had transferred from Ottoman to Bulgarian control the previous year.

A3901 Stéphane Passet

Constantinople, Turkey 29 October 1922
This view over Constantinople was taken at a turning point in the city's history. In the background British and French gunboats are patrolling the Bosphorus in support of their land forces, which occupied the city at the end of the First World War. Following the insurgency by Turkish nationalists led by Atatürk, the Western powers eventually evacuated the city in September 1923. Constantinople was officially renamed Istanbul; Istanbul was replaced by Ankara as the Ottoman capital; and the empire itself was dissolved, giving way to the new Republic of Turkey.
A36317 Frédéric Gadmer

Adrianople, Turkey 4 November 1922
To record the effects of the immense population shift caused by the war, Gadmer went to the railway station at Adrianople, a city now known as Edirne in western Turkey. The juxtaposition of the soldier looming over the anxious faces of people in a cattle-truck provides a chilling foretaste of the barbarities yet to unfold in this brutal period of European history.
A36430 (above) and A36432 (opposite, detail) Frédéric Gadmer

Karaköy, Turkey 18 December 1922
The Greek army's scorched earth policy during their retreat across Anatolia destroyed countless buildings. In this picture, a displaced person has little alternative but to sell his wares from a rug on open ground, probably near Karaköy in the Turkish province of Bilecik. A36854 Frédéric Gadmer

Alasehir, Turkey 8 January 1923

In the city of Alasehir, which in antiquity was known as Philadelphia, Greek forces were accused of creating a firestorm that destroyed 70 per cent of its buildings. Many perished in the course of the outrage, while desperate survivors sought shelter wherever they could find it – even, as here, in a hollow tree-trunk.

A37253 Frédéric Gadmer

Smyrna, Turkey 15 January 1923
This street is in the Italian quarter of Smyrna. One of the Mediterranean's most ancient cities, it was long feted for its wealth and beauty. After the Graeco-Turkish War, Smyrna's glories were nowhere to behold. To this day, responsibility for this destruction is disputed, but as Gadmer's autochromes show, the extraordinary scale of the devastation cannot be denied. A37418 Frédéric Gadmer

Usak, Turkey 6 January 1923
The incinerated carcass of a locomotive lies upended on the strategically important railway line near the city of Usak, around 150 miles east of Smyrna. Usak was the scene of immense destruction during the Greek army's westward flight in September 1922: it has been estimated that during the fighting around one-third of the city was obliterated.

A37214 Frédéric Gadmer

Manisa, Turkey 12 January 1923

These civilians have gathered in the city of Manisa in western Turkey, after it had been torched by retreating Greek forces. One American diplomat reported that 10,300 houses and fifteen mosques in Manisa had been destroyed. The man squatting on the far left of the front row of this group was driven mad after being trapped in a burning building.

A37371 Frédéric Gadmer

Constantinople, Turkey 24 November 1922
A year before Gadmer's visit, the Turkish authorities had turned the Topkapi Palace in Constantinople – home to the Ottoman Sultans since the fifteenth century – into a museum. Hitherto, in the Topkapi Audience Hall, the Sultan had received reports from his ministers while seated on this, his emerald encrusted golden throne. A36604 Frédéric Gadmer

4 The First World War

The Battle of Verdun began on 21 February 1916 and lasted ten months. It accounted for 260,000 lives, almost one a minute. In the long run, no one got much further because of it, but that did not bother German Chief of Staff Erich von Falkenhayn. What he wanted, above all, was bodies.... Falkenhayn understood the mentality of the French generals very well. They threw everyone and everything they had into the fray, thinking only of glorious attacks, and were barely concerned with the lives of their troops. That is reflected in what remains of the French trenches: shallow and makeshift, in contrast to the German concrete. Verdun was a trap for the French Army, with pride and glory as its bait.

Geert Mak, *In Europe*, 2004

Most photographers who were assigned to cover French operations in the First World War never witnessed the blood-drenched spectacle that was the Western Front. This was neither for want of desire nor deficit of courage. Although it was not widely known at the time, the few who were granted permission to observe events at the front were subjected to rigid controls imposed by censors working for the French army. In war – then as now – media management was deemed an unfortunate but unavoidable military necessity.

▲ Kahn's photographers captured troops during their most intimate moments – in bed, or even at a camouflaged urinal. A11030 Stéphane Passet (top: Verdun, 1916); A12834 Paul Castelnau (1918)

◀ Soldiers in a trench at Le Hamel in the *département* of the Somme on 9 August 1915. Very few autochromes depict men actually engaged in combat. A5940 (detail) Stéphane Passet

▲ The catastrophic casualty rates of 1914 have been partly blamed on the red trousers that had been part of the French army's uniform since the Franco-Prussian War A6803

Kahn's collection allows us to glimpse not the drama of combat but the stultifying routines and overwhelming banalities of war.

Conceivably, the zeal of the French army censors might have rendered Kahn's autochromes frustratingly anodyne or ersatz. Indeed, working under such constraints, it was always likely that Kahn's team would produce images that were partial and oblique – like the shadows cast by the war, rather than direct and unfiltered representations of the conflict itself. Yet by exercising considerable ingenuity, Kahn's *opérateurs* produced pictures that were subtly indicative of the slaughter that was taking place.

Several autochromes testify to the many deadly misjudgements made by the French generals before and during the war. The High Command had resisted demands to replace the traditional bright blue tunic and vivid red trousers of the army uniform with something that camouflaged their men. The historian Richard Holmes has deftly summarised the grim consequences of this awful blunder:

Even though they had served in the French army, and had agreed to share many of their autochromes with its photographic unit, the *opérateurs* working for Albert Kahn in the war zone were not exempt from the code. For the most part, their cameras remained in relative safety behind the front line, so their war photographs do not offer anything like the whole, unmitigated and abysmal truth. Their pictures present us with a different, though no less authentic, reality.

They went into battle in these wildly impractical uniforms using wildly impractical tactics – and paid a huge price for it. The first year of the war, which only involved fighting for some five months, is the most expensive in terms of dead of all the war years for the French army. So those people who'd said before the war that there was something distinctively French about the red trouser were responsible for carpeting the hills of the Franco-German border with lots of dead conscripts.

Eventually, the traditional colours were replaced by a more muted shade known as *bleu horizon*, which, once sufficiently muddied, allowed the men to blend into the frosty earth at the Western Front.

Mud, of course, was hardly in short supply. From the autumn of 1914 onwards, for most French troops home was a rancid, rat-infested trench. As the Kahn autochromes show, many trenches were ramshackle affairs. Latrine facilities ranged from the merely inadequate to the practically non-existent. Men wounded by the incessant gunfire and shelling had their slim chances of survival further diminished by the insanitary conditions. Nor could French casualties expect speedy treatment from their medical services. In another demented policy error, it had been decided that the injured should be treated at a hospital near where they had enlisted. The delays denied many men the prompt treatment that might have saved their limbs, or their lives.

In October 1915, Auguste Léon was allowed to see at first hand some of the injuries sustained by the troops. At a hospital in the Loiret *département* of northern France he photographed the bone infections, shrapnel wounds and soft tissue scarring on the bodies of the combatants. Many of their faces address the camera with stoicism: in others, a grimace provides a sharp reminder of the suffering that some of these fighting men had to endure.

Throughout the conflict, Kahn's cameras would return to hospitals all over France. Nurses figure prominently in a number of autochromes; in his pictures,

▲ Nurse Mireille Andrieu became one of the first women to be awarded the *croix de guerre*, for saving lives in the beseiged French town of Soissons. A72824 Fernand Cuville (1917)

as in the newspapers of the day, they were often represented as archetypal 'invasion heroines', working selflessly, often in the danger zone, to save the lives of those who were so valiantly fighting the Boche. One picture, taken with characteristic panache by Stéphane Passet at a hospital near the Somme in July 1916, was composed with special care. In it, the nurse has a lambent patina – almost an aura – that reinforces the near-mythic lustre of her profession.

▲ Two of Kahn's key war photographers, Fernand Cuville (left) and Paul Castelnau, photographed at Kahn's home near Paris on 16 January 1918. A13099 and A11907 Auguste Léon (both)

▶ This autochrome of June 1917 appears to show soldiers preparing for an anti-aircraft attack in the village of Bucy-le-Long, 2 miles east of Soissons. A12343-AT (detail) Fernand Cuville

Some of the seated portraits of nurses convey the same message. Pinned to their bosoms are medals awarded for their service in the war – official confirmation of their dedication, courage and sacrifice.

Almost from the outset of the campaign, the French army understood the importance of photography for military reconnaissance as well as propaganda purposes. In the spring of 1915 the High Command established a special photographic unit known as the Section Photographique et Cinématographique de l'Armée. Kahn came to a mutually beneficial arrangement with them. Shots were taken twice, with one set going to the army and the other to the Archives of the Planet.

By 1917, two of the fifteen soldier-photographers in this unit were shooting images of the conflict simultaneously for the army and for Kahn's Archives. Fernand Cuville (1887–1927) had enlisted as an infantryman, but it is evident that when in contact with other human beings he preferred pointing a camera at them rather than a bayonet. Like his *confrère*, the music- and literature-loving Paul Castelnau (1880–1944), Cuville had the disposition of the creative artist rather than that of the killer. Together with the autochromes shot by Kahn's other photographers, principally Auguste Léon, Stéphane Passet and Georges Chevalier, around fifteen hundred colour pictures were taken. Many were shot just behind the battle front, or in the towns and villages devastated during the fighting. These pictures constitute one of the world's largest and most significant collections of colour photographs documenting the everyday experience of soldiers and civilians in the First World War.

Moreover, their previous experience as troops afforded Cuville and Castelnau a personal appreciation of, and instinctive empathy with, the experiences of the rank-and-file soldier in the French military.

▲ Mundane moments in the midst of an earth-shattering event: soldiers peel carrots at an encampment in Rexpoëde, near Dunkerque, on 31 August 1917. A12833 Paul Castelnau

Often a silent communion between the photographers and the men is readily apparent in their pictures. Their works – which Jay Winter has described as 'photographs of great affection, and of enduring solidarity with the men in uniform' – are perhaps exemplified best in the autochromes that reflect the mundane realities of military life. A war that is vast, global and epoch-making is represented here in the small, local and everyday. In these pictures we see that a war that involved the killing or maiming of half a million Frenchmen at Verdun also required twenty-odd soldiers to peel carrots at a camp near Dunkerque. We are reminded that a conflict that mechanised slaughter also saw men drying their long johns at a camp in Alsace. In Albert Kahn's autochromes, the colossal edifice of a world war is bathetically reconstituted and reframed down to the human scale.

A conflict that would ultimately precipitate the collapse of four empires – the German, Austro-Hungarian, Russian and Ottoman – would also bring to Europe huge numbers of colonised subjects from the overseas dominions of Britain and France. For many years, historians either downplayed or overlooked the stories of the colonial troops at the Western Front – but Kahn's autochromes exhume that buried narrative.

Estimates vary, but at least two hundred thousand, and possibly as many as four hundred thousand, troops were drawn from the French colonies. One of the largest contingents consisted of African conscripts from the colonies of Senegal, Ivory Coast and Guinea – but the French blithely disregarded their actual origins and labelled them all Tirailleurs Sénégalais, or Senegalese Riflemen. The army also had battalions of Zouaves, the hard-nosed and hard-living fighters recruited from among the French *pieds-noirs* settlers in the North African colonies, principally Algeria and Tunisia. In addition, about

▲ Left to right: a Tirailleur Sénégalais; a *poilu* with a tattoo of Napoleon on his back; a Tirailleur Indochinois.
A12040 Paul Castelnau; A6771 André Bernardel; A12284-AT Stéphane Passet

fifty thousand troops came from Indochina; like their brothers-in-arms from Africa, the Tirailleurs Tonkinois (from present-day Vietnam) and Tirailleurs Cambodgiens (from Cambodia) always fought under the command of French officers.

The Zouave regiments were both respected and feared. Together with the Tirailleurs Sénégalais and the recruits from Indochina, they figured in several important battles. The African troops fought alongside Canadian and British forces at Vimy Ridge and the Somme; and they joined the US First Army at both the Battle of St Mihiel and the huge Meuse-Argonne offensive of September 1918.

In the final year of the war, more than seventy-seven thousand troops from the sub-Saharan African colonies provided a vital injection of manpower into a French army that was badly depleted, horribly demoralised, thoroughly battle-weary and utterly bedraggled. But they were by no means the only newcomers to the European theatre. The African presence was dwarfed by the American Expeditionary Force, which by 1918 was landing many thousands of troops on French soil every month.

By July 1918, well over a million US soldiers were serving in France; that year, Kahn's cameramen filmed them marching with a swagger down the Champs-Élysées. But most had arrived too late to see action at the Western Front. By the time of the Armistice on 11 November, the shells of both sides

▶ Foreign Minister Aristide Briand (centre) leads the French delegation to the 1926 talks at Locarno in Switzerland. The agreement that followed maintained peace in Europe for a decade – until Hitler repudiated the pact by ordering German troops to reoccupy the Rhineland in 1936. A47663 Roger Dumas

▼ Residents sit amid the ruins of a house in Meurthe-et-Moselle on 27 April 1915. A5361 Georges Chevalier

had pulped the verdant landscape of northern France into a silent, grey wasteland. Four years of incessant bombardments had stripped swathes of the country of its wildlife, buildings and people.

Kahn's *opérateurs* deployed the army's reconnaissance aircraft that had survived the conflict to shoot their shattered homeland from the skies. In some of the Archives of the Planet's most shocking images, the horrendous scale of the cataclysm unfolds. Their airship casts its giant shadow over farmlands emptied of people and livestock. They glide over the mangled remains of mutilated towns. Below them, in the historic city of Reims, the thirteenth-century cathedral – where once the kings of France were crowned – is reduced to a blasted remnant.

Arras, too, is a scene of near-total oblivion. In the aerial films shot by Kahn's cameramen, vast areas of northern France seem to have been visited by a devastation of apocalyptic proportions.

Such images would have appalled the most flint-hearted of viewers, let alone a sensitive pacifist like Albert Kahn. These films are an inestimably important historical record of the war's disastrous impact on the French landscape. Yet it is the up-close and earthbound autochromes, images revealing the

impact of the war on the individual rather than the panoramic and airborne perspective of the calamity, that anchor themselves most insistently in the consciousness. In Kahn's Archives, explicit images of the obliterated heads, smashed arms and shattered sinews of the 8.5 million dead and 21 million wounded are substituted by the richness of what Kahn's photographers produced instead: a meticulous, intimate and humane examination of the ordinary experience of people trapped in an unfolding global catastrophe.

After the war, across much of Europe many people wondered how their countries should commemorate the newly dead. In France, one of the nations most vastly bereaved, families were mourning the passing of around 1.3 million of their countrymen. British losses, standing at just under a million, were only marginally less obscene. Nationals of both countries expected their homelands to find an appropriate way to mark this colossal sacrifice.

France responded by building some thirty-eight thousand monuments all over the country. Among the most significant is the giant ossuary at Douaumont, which contains the skeletal remains of thousands of the fallen – mostly the victims of what some historians have termed the 'mincing machine' that was Verdun in 1916. Britain built almost as many (though generally less ghoulish) monuments to its dead. The most famous was the Cenotaph in London's Whitehall, which Kahn's *opérateur* Fernand Cuville photographed in July 1919. His visit coincided with the scheduled 'victory parade', when fifteen thousand troops from fourteen of the allied nations marched for two and a half hours through London. This procession was the precursor of the annual Remembrance Sunday ceremony, which, since its debut in 1921, has become, as Jay Winter suggests, the most sacred of all secular events in the national calendar: its unique place in the British national consciousness remains undimmed almost a century after the appalling event it so powerfully commemorates.

▼ Stark, severe and sacred: Sir Edwin Lutyens's original wooden Cenotaph in Whitehall, seen here on 23 July 1919, was later remade in Portland stone, and would become Britain's most revered secular monument. A18309 Fernand Cuville

Reims, France 1 April 1917
In one of the Kahn Archives' most striking images, this cyclist orderly has stopped for lunch at Place Royale in Reims. Although the Allies did construct fixed-line telephone networks along the Western Front, communication systems were always vulnerable to enemy shells. During many battles, runners and cyclist orderlies remained the quickest and most reliable way to feed information back to command headquarters. A72750 Paul Castelnau

▶ **Reims, France** 1917
In the trenches, where conditions were invariably muddy, rancid and blood-soaked, few cleaning facilities were available to the soldiers. When they were relieved from action at the front, the men took advantage of any opportunity they could find to wash themselves. Here civilians assist a *poilu* during his ablutions on a street in Reims.
A11816 (detail) Fernand Cuville

Vauxrot, France June 1917

In a support or reserve trench in the village of Vauxrot, north of Soissons, these troops are having soup. By the summer of 1917, morale among the French rank and file was very low, and the poor quality of their rations did little to improve their mood. But for the German combatants, provisions were even worse: Allied naval blockades meant that the German *Frontsoldat* would soon be eating bread made from sawdust. A12307-AT Fernand Cuville

Largitzen, France 18 June 1917

These men are eating soup in front of their shelter in Largitzen in Alsace. Known in French military slang as *cagnas*, such shelters were often dug out of the landscape. Here the troops appear to have built their *cagna* around an A-frame, and thatched its roof to provide extra protection from the elements.

A12068 Paul Castelnau

Le Ployron, France 1916
The repellent conditions in the trenches encouraged many troops to improvise shelters of their own. This straw wigwam, built near the village of Le Ployron in the Picardy region, might have been slightly less insanitary than the accommodations at the front, but it would have given these men little protection from enemy shells. A7234 Stéphane Passet

Ricquebourg, France August 1915
Standing out among this group of *poilus* cleaning the rubble out of a trench at Ricquebourg, near Amiens, is a man sporting a broad red cummerbund – a touch of what the military historian Richard Holmes has called the 'Gallic bravura' of the men at the front.
A6722 Stéphane Passet

Oise, France 21 July 1915
These men are standing in a 2-mile-long trench linking front line battery positions between Conchy-les-Pots and the Bois des Loges in the *département* of Oise. Communication trenches were cut at an angle to those facing the enemy. They were used to transport men, kit and provisions to the front line – and take the casualties back. A5883 Stéphane Passet

St Claude, France 1 August 1915
One year into the war, these dishevelled and weary-looking artillerymen peer out from shelters hollowed out of rock in a trench at St Claude, around 30 miles north of Paris. A5908 Stéphane Passet

Eglingen, France 23 June 1917
This *guetteur*, or watchman, is on the lookout for enemy activity at Observation Post 26 at Eglingen, in Alsace. Around him we can glimpse the chaotic conditions in a typically ramshackle French trench.
A12098 Paul Castelnau

Hirtzbach, France 16 June 1917
This soldier's-eye view of the terrain beyond the trenches was shot from an observation box in the town of Hirtzbach in Alsace. The life of the lookout was unglamorous and, in quiet sectors such as this one, often downright tedious. Those assigned to observation duty could face weeks, even months, of vigilance: but many lives depended upon their attentiveness. A12048 Paul Castelnau

Saint Ulrich, France 16 June 1917
In a series of autochromes Castelnau observed the work of a group of Tirailleurs Sénégalais based at St Ulrich near the border with Switzerland. In most of these images, they are engaged in mundane tasks: here the man on the left is peeling an apple.
A12042 Paul Castelnau

Provence, France 19 April 1916
In their striking red tunics, voluminous blue trousers and conspicuous white burnouses, these men belong to one of the Spahi regiments that had been mobilised at the Château de Tarascon in Provence. Seven regiments of Spahi cavalrymen recruited from the French colonies of North Africa fought as part of the French army on the Western Front during the First World War. A8113 Georges Chevalier

◀ **Steenkerque, Belgium** 5 September 1917
Stationed in the Belgian town of Steenkerque, around 30 miles southwest of Brussels, is this contingent of troops with a 370-mm railway gun mounted on a bogie (wheeled undercarriage).
A12920 (detail) Paul Castelnau

Oise, France 21 July 1915
Embedded deep in the forest is an emplacement for a 75-mm cannon. Propped up against the branches on the left of the picture stands a cross-cut saw, which suggests that this position was of relatively recent construction. A5888 Stéphane Passet

Loo, Belgium 5 September 1917
Paying a visit to this gunboat moored on the Canal de l'Yser near Loo was King Albert I of Belgium. Earlier in the war Albert had successfully commanded Belgian forces at the Battle of the Yser, preventing Germany from gaining further control of the North Sea coast. A12926 Paul Castelnau

Dunkerque, France 3 September 1917
These men are Fusiliers Marins – members of a naval unit specialising in defending onshore installations and supporting marine commandos. It is likely that less than three weeks before this picture was taken these men had been among the forces that secured a bridge-head at Drie Grachten near Dunkerque – a rare success for the Allies in the mostly disastrous Third Battle of Ypres. A12878 Paul Castelnau

Paris, France October 1918
This is part of the German L49 Zeppelin dirigible that was put on show at the Jardin des Tuileries in Paris. After taking part in a bombing raid on England in October 1917, this airship was forced down by French pilots near Bourbonne-les-Bains in eastern France. The L49 was the only German airship captured intact: when they were brought down, most Zeppelin pilots destroyed their craft to avoid their technology falling into enemy hands. Such spoils of war were often put on display as concrete evidence of success. A14723 Auguste Léon

The Somme, France 2 March 1916
These aviators are preparing for take-off in a Farman MF.11 Shorthorn biplane on an airfield near the Somme. In the early phase of the war these aircraft proved their worth on reconnaissance missions and light bombing raids, but by mid-1916, the superior German Fokkers had made the MF.11 obsolete. A7242 Stéphane Passet

Thann, France 6 June 1917

After visiting the shattered town of Thann in Alsace, an American reporter wrote: 'When a roof in Thann is destroyed, no one mends it. What is the use? The Germans are within a mile of Thann and can ruin it at will. Now and again they send over a few score shells. They call them forget-me-nots.'

A11997 Paul Castelnau

Reims, France 1917
These children are playing skittles amid ruined buildings in the Place d'Erlon in Reims. With the completion of its ornate Subé Fountain in 1906, this square had become one of the most elegant in Reims. A decade later, successive German bombardments destroyed much of the square – though the fountain itself did survive the war.

A11602 Fernand Cuville

Reims, France 6 April 1917
Reims was being besieged by German forces within thirty-five days of the start of the war, and for much of the conflict it remained within artillery range. The long years of shelling devastated a place of great historical importance: traditionally, French kings were crowned in the city's magnificent Gothic cathedral. A11566 Paul Castelnau

Reims, France 1917
Known as Soldats du Génie, these men belong to the French Army Engineers. Here they may be trying to salvage construction materials from the ruins of this bombed building in Reims.

A11722 Fernand Cuville

Chivres-Val, France July 1917

This cluster of junior officers belonging to the 370th Infantry pose amid the ruins of a building at Chivres-Val, near Soissons. Cuville's study of the camaraderie among the French servicemen was probably produced shortly after these men were attacked at Chemin des Dames – a strategically important ridge in the Aisne, on 8 July 1917.

A12390-AT Fernand Cuville

Turckheim, France 3 October 1919
In an image reminiscent of the paintings of the acclaimed war artist Paul Nash, this perished forest near the town of Turckheim in the foothills of the Vosges was probably torched by the retreating German army. In the years since this cataclysm, Turckheim has become one of France's *villes fleuries* – a town celebrated for its preponderance of flowers.
A18520 Fernand Cuville

Conchy-les-Pots, France 24 July 1915
These men from the 98th Infantry are taking furniture and other domestic items from a house at Les Loges, near Conchy-les-Pots in the Oise. Technically, this may well have been an instance of looting; but many troops would consider this to be a legitimate form of salvage, enabling them to acquire a few creature comforts that would humanise the otherwise rotten conditions in the trenches. A5896 Stéphane Passet

Reims, France 6 March 1917
During the war, these firemen pushing a hand-cart bearing a water tank through the streets of Reims would have been among the busiest in all France. After a shell onslaught in 1914, an inferno raged through the city, consuming one of the country's great symbols – the city's medieval cathedral.

A11589 Fernand Cuville

Reims, France 1917
The name of this little girl is lost to us, but the juxtaposition of a young innocent at play with the cold, steely menace of those unguarded rifles makes this image one of the most potent and poignant of all the autochromes in the Kahn Archives.
A11824 (detail) Fernand Cuville

Reims, France 5 April 1917
This extravagantly moustachioed, hard-hatted figure is a postman who is delivering mail in Reims. By this time the city had already endured sustained attacks, but it was about to see yet more destruction, as on 16 April over a million French troops gathered for the disastrous Nivelle Offensive between Soissons and Reims. A11548 Paul Castelnau

Reims, France 6 March 1917
This soldier is making enquiries about the cold meats on sale at this reasonably well-stocked *charcuterie* in Reims, where wooden planks have been used in a futile attempt to fortify the shopfront.

A11605 Fernand Cuville

Beaugency, France 20 August 1915
Taken at a military hospital in Beaugency near Orléans, this autochrome shows a French soldier being treated for an eight-month-old injury to the humerus. On top of the 8.5 million troops who died in the war, a staggering 21 million men were wounded, of whom about 947,000 were French.
A6794 Auguste Léon

Moreuil, France 30 July 1916
Nurses Coloimbet, Louis, Egot and Flageollet pose with soldiers at a French military hospital in Moreuil, in the *département* of the Somme. This picture was taken a month after the start of the Battle of the Somme, when 58,000 British troops were killed or injured – the worst single-day losses in the history of the British army. A7794 Stéphane Passet

Roesbrugge, Belgium 7 September 1917
These men are recuperating outside what is probably the No. 36 Casualty Clearing Station (CCS) at Roesbrugge, on the Yser River. Often located near railway lines close to the battlefronts, these stations were created to give speedy – often life-saving – surgical treatment to the injured before their transfer to field hospitals, which were usually positioned further from the action.

A12940 Paul Castelnau

Moreuil, France 30 July 1916
Sunlight kisses the uniform of a nurse tending to casualties at a chateau that has been converted into a hospital at Moreuil, around 10 miles southeast of Amiens. In this autochrome, Passet's chiaroscuro lighting gives his heroine an angelic radiance.
A7795 Stéphane Passet

Craonnelle, France 27 August 1919
For years after the Armistice, the French had the gruesome task of burying the bodies of around 1.7 million of their fallen countrymen, as well as millions more fatalities from the other combatant nations. Here a French *poilu* oversees German prisoners of war digging graves at Craonnelle, 15 miles northwest of Reims. This cemetery contains the remains of nearly four thousand French, British and Belgian troops. A17538 Georges Chevalier

Aisne, France post-war, date uncertain
Kahn's Archives of the Planet contain very few images showing the bodies of the men who perished in La Grande Guerre, but of those it does possess, this autochrome, taken near Chemin des Dames in the *département* of Aisne, is perhaps the most explicit – and distressing.
A74356X Photographer unknown

Moreuil, France 15 August 1916
A priest gives communion to this group of soldiers at Moreuil, near Amiens. Anti-clericalism was strong within the French army during the early part of the twentieth century, and attendance at church services was actively discouraged; however, many in the lower ranks found solace in the Catholic mass.
A7812 Stéphane Passet

Moreuil, France 30 July 1917
French troops gather in a cemetery at Moreuil
for a mass funeral of comrades who had died during
night-time German attacks on French trenches at
nearby Lihons on 28 and 29 July 1917.

A7787 Stéphane Passet

London, England 19 July 1919
Union flags and French tricolours flutter above the lines of allied troops filing through Knightsbridge during the post-First World War victory parade in London. 15,000 soldiers took part in the event, many of whom had bivouacked in nearby Kensington Gardens, while hundreds of civilians camped overnight on the streets to secure a favourable vantage point from which to observe the procession. A18233 Fernand Cuville

London, England 19 July 1919
Flags flutter outside office windows overlooking Parliament Square ahead of the planned victory parade. Led by the commanders of the Allied Powers, the procession was reviewed by King George V from a specially constructed pavilion outside Buckingham Palace.

A18238 Fernand Cuville

London, England 21 July 1919
Two days after the victory parade, shops in central London were still emblazoned with banners – but as this picture of a near-deserted Piccadilly Circus shows, the mood was sombre. The buildings proclaim victory, but that message is overwhelmed by an atmosphere of mourning, a sense of absence, and the presence of loss. A18249 Fernand Cuville

Düsseldorf, Germany 11 May 1921
These Belgian troops guarding a bridge in the city of Düsseldorf were part of the allied army of occupation in the Rhineland. Around three-quarters of a million French, British, US and Belgian troops were stationed in this strategically vital territory on the Franco–German border. Their presence was a source of great consternation among the Rhineland's civilians, who often complained bitterly of mistreatment, especially by the French. A26833 Frédéric Gadmer

Ratingen, Germany 11 May 1921
Resting near the town of Ratingen, north of Düsseldorf, is a *fanfare de cavalerie* – a military band in the French cavalry. Allied forces remained in the Rhineland until 1930, at which point (according to the Treaty of Versailles) it ought to have become a demilitarised zone: but that agreement was brazenly ignored by Adolf Hitler, who ordered German troops to reoccupy the region in 1936.

A26840 Frédéric Gadmer

5 The Far East

Saturday, 12 December 1908 was an unusual day in the life of Albert Kahn's chauffeur, Alfred Dutertre, because, as far as he was concerned, it never really happened. As Dutertre's diary entry explains: 'This day did not exist for us. In effect we reached the 180th degree of longitude, and at that point we were an equal distance from Paris to the west and east. Up until now we have been putting our watches back by an hour every day until we were 12 hours behind Paris. We now went forward in time by 24 hours in one go, so we are now 12 hours ahead of Paris to the east.' Six days after Kahn and Dutertre crossed the International Date Line – which effectively marked the halfway point in their circumnavigation of the globe – the SS *Mongolia* eased into one of Asia's great port cities. By the time Kahn and Dutertre made their landfall, Yokohama was already established as a trade and industrial powerhouse. In 1908, it was home to many Japanese merchant families who had profited handsomely by trading silk to Europe.

For many years, Japan had occupied a special niche in the affections of Albert Kahn. The roots of his fascination can be traced back to the end of the nineteenth century, when he brokered loans that funded railway construction projects in what was then Japan's colony of Taiwan, as well as its pseudo-protectorate, Korea. By 1899, Kahn had developed close working relationships with some of the most influential figures in Japan's emerging financial sector. Among the closest of his associates was Viscount Eiichi Shibusawa, the founder of what would eventually become one of the world's biggest financial institutions, the Dai-Ichi Kangyo Bank. The full extent of Kahn's involvement in Japanese high finance is difficult to assess with any certainty: many of his deals, it appears, were conducted in considerable secrecy. It is not unreasonable to suppose that Kahn's discretion was an appropriate response to the political context, which was overshadowed by the lurking prospect of war between Japan and Russia.

In the 1890s, Russia had received loans from several European financial institutions for military procurement and major infrastructure projects, including extensions to the Trans-Siberian Railway. This investment had significantly increased Russia's ability to expand its empire further into the Far East – a development that Japan viewed with alarm. The rivalry between them intensified until eventually, in February 1904, Japan declared war on Russia. As an ally of Russia, France was urged to discourage its

◀ Japan, *c.* 1912. The monk Benkei crosses swords with the child Ushiwaka on Kyoto's Gojo Bridge in a scene from the Noh theatre classic *Hashi Benkei*. A6592 (detail) Stéphane Passet

▲ Kahn sits with Prince Naruhisa and Princess Fusako Kitashirakawa of the Japanese imperial family at his estate at Cap Martin in February 1923. C1310 Roger Dumas

bankers from making loans that might help the Japanese war effort. Despite this, Albert Kahn played a central role in brokering at least three of the seven most substantial foreign loans procured by Japan in this period.

In 1905, Japan secured a resounding victory over Russia. But the cost of the war had left Japan's economy in a fragile state. During Kahn's 1908 visit, it is almost certain that some of his discussions with the lions of Japan's political and financial world would have touched on the possibility of his securing the cash that the country so urgently required. There is little doubt that by the time of these encounters, Kahn was greatly esteemed as a trusted intermediary between the European financial markets and Japan: at a lunch organised in his honour, he was presented with three gold dishes – a gift from Emperor Meiji himself.

During his three-week stay in Japan, Kahn was received at the homes of some of the country's most important statesmen, including two former Prime Ministers, the Marquis Matsukata and Kahn's close friend Count Shigenobu Okuma. It is clear that Okuma and Kahn's mutual affection and respect were grounded in their shared internationalist outlook. In a speech given a few months after the Frenchman's visit to Japan, the Count expressed his sympathy with his values: '[On each of Kahn's trips to Japan] I met him and we got on so well that he wrote to me from France.... His dream is to unify the world of the future.... This means that racial and religious intolerance must be destroyed. I have in fact spoken of a similar idea to this – the unification of the world – in the conclusion of my Fifty Years Chronology.... He was pleased to find the same argument here.'

According to Dutertre, on 7 January Kahn's entourage visited the palatial residence of one of Japan's most powerful industrialists. Soichiro Asano was the founder of a conglomerate that would

▲ Guests gather in the gardens at the Tokyo home of Japan's Ambassador to France, Ichiro Motono, during Kahn's visit to Japan in 1909. D4621 Alfred Dutertre

acquire significant interests in cement, oil, mining, shipbuilding and steel. The French travellers were circulating at the most exalted levels of the country's political, financial and business elites – yet, as sophisticated, metropolitan and Westernised as Japan evidently was, the country inflicted a succession of culture-shocks upon Dutertre. When he accompanied Kahn on visits to the homes of wealthy business contacts in Tokyo, Dutertre was surprised to discover that Japanese houses had few items of furniture. He was bemused also by the behaviour of shop assistants, who tried to protect the floors of their emporia from the grubby soles of visiting Westerners by insisting that their customers don over-slippers before entering their stores. To Dutertre, such obsessions were further evidence of what he called the 'excessive cleanliness' of the Japanese people.

But in the next country on their itinerary, China, Dutertre was not troubled by a surfeit of hygiene. On 13 January 1909 Kahn's party left Japan, and two days later arrived in Shanghai. After paying what he considered extortionate customs fees and having two crates of his photographic equipment confiscated, Dutertre's unfavourable impression of the country was formed right from the start. One early diary entry reads: 'So here we are in China. An enormous difference from Japan. Greater poverty and a revolting dirtiness.'

Conditions in the so-called international concessions were much more to Dutertre's liking. Autonomously administered, governed and occupied by nationals from the West – mainly expatriates from France, Britain, Japan and the USA – these districts boasted impressive boulevards lined with neatly manicured Western houses. From this area, as with its Beijing counterpart – the Legation Quarter, situated just to the east of Tiananmen Square – the Chinese population was excluded. Not surprisingly, many Chinese nationalists came to detest the concessions as painfully symbolic of China's weakness, especially in relation to the Great Powers of the West.

But at the time, many European travellers enjoyed the atmosphere inside these enclaves, which for

▲ A woman with bound feet visits the Temple of the Tamed Tiger on Mount Emei on 9 June 1913. Her red laces suggest that she is from a prosperous family. A1353 Stéphane Passet

visitors could seem almost carnivalesque. After watching soldiers in the German colony preparing to celebrate the birthday of Kaiser Wilhelm II, Dutertre wrote: 'The barracks in particular are decorated with great taste, and a festival is held there at night. I notice the great camaraderie that unites the French and German soldiers barracked in Beijing.' Of course, Dutertre could not know that within five years the men demonstrating such *bonhomie* would be on opposite sides of the bloodiest war the world had ever seen.

Outside the concessions, the picture was very different. Dutertre expressed shock at the ubiquitous poverty and squalor, and was alarmed by the physically exhausting tasks undertaken by the Chinese manual worker. After observing that 'all carrying is done on men's backs', he noted that they would earn between 45 and 50 centimes per day. Even in 1909, this was a dismal return for such arduous labour. Dutertre was similarly unimpressed by some of the country's cultural practices, including the ancient tradition of foot-binding. He reported: 'The custom consists of breaking the bones in young girls' feet at the age of 7 or 8, and then binding the foot in bandages in such a way that it folds the toes and the heel under the sole of the foot.... This causes atrocious suffering and leads to the death of many young girls.'

If Dutertre found some of China's mores disturbing, he had fewer problems appreciating the majesty of the fifteenth-century human and animal statues at the celebrated Ming Tombs, some 30 miles northwest of Beijing. He and Kahn intended to follow this experience by visiting an even more famous Chinese cultural treasure, the Great Wall, which they hoped to visit on 24 January. But that plan proved abortive: to their chagrin, the Chinese New Year celebrations had already begun and train services to the Wall had been cancelled. Extravagantly, Kahn tried to charter a special train to take his entourage there, but the stationmaster would not countenance the suggestion.

▲ Kahn's chauffeur and photographer Alfred Dutertre rides a trusty steed at a stable near the city of Nikko, around 100 miles north of Tokyo. D1229

▲ In this photograph by Alfred Dutertre, Kahn (second from right) gestures to a passer-by at Nankou Pass near the China–Mongolia border. D2638 Alfred Dutertre

The travellers returned to Beijing but, not to be denied, a week later Kahn and Dutertre did reach the Great Wall. After boarding an open goods wagon – which they shared with a donkey – they arrived at the Nankou Pass. This rocky pathway linked the Chinese frontier town to Kalgan, a key border settlement in another country that fascinated Albert Kahn: Mongolia. Yet Kahn and Dutertre did not venture over the border with their cameras. Instead, the following morning they went back to Beijing, and five days later boarded the boat that would take them home to France. But four years on, Kahn's photographic collection would be spectacularly embellished by the addition of autochromes from this ancient and endlessly intriguing land.

In the spring of 1912, Stéphane Passet embarked on the first leg of what would be one of the most important and productive missions ever undertaken for Kahn's Archives. Judging by the progress reports he sent to his employers in Boulogne-Billancourt, Passet was a man not given to understatement: in general, his writing style veers between the entertainingly grumpy and the downright splenetic. Notwithstanding this, Passet's pre-war passage to the Far East could never be described as uneventful, and his expressions of vitriolic exasperation were seldom entirely unjustified.

▲ The intrepid Stéphane Passet visited Mongolia for a second time in the summer of 1913. In this self-portrait, taken near the Russia–Mongolia border, Passet steps in front of his own lens just after bagging his lunch. A5469

Passet had planned to take the overland route to Asia, on Russia's Trans-Siberian Railway. But at the time, the vast Russian empire was in a state of extreme political volatility. The first Russian Revolution, in 1905, had left Tsar Nicholas II clinging to power, but the threat of further revolution created a febrile atmosphere. So when Passet tried to transport his cargo of hi-tech photographic equipment into Russia, it is hardly surprising that he was greeted with suspicion. In a letter to the French Consulate in Moscow, dated 29 May 1912, Passet takes up the story:

On arrival in Alexandrovo, I showed my train ticket and told them we were just in transit but despite this, customs officials started to break into my nine trunks with hammers and turn them upside-down! I had to physically force them to stop. They only managed to do this to two cases of glass plates and didn't break the camera or bottles of solution.... When I got to Hotel Metropole in Moscow I gave in my passport, and then shortly afterwards the police arrived to interrogate me and they confiscated my passport until my departure.

It required the personal intervention of the French Consul before Passet's equipment was returned. But the photographer's problems had only just begun.

He eventually arrived in China a mere four months after the abdication of Hsuan T'ung, otherwise known as Pu Yi, the last Emperor of China. The boy had ascended to the throne at just three years of age – but the infant potentate was ruling over an empire that was already breaking apart. By June 1912, when Passet reached Beijing and started recording the life of a city that had just been declared the new capital of China, the country was already on the verge of political disintegration. Despite the instability,

Passet shot around four hundred colour images in China. Mostly, his autochromes feature timeless representations of rural Chinese life. Agricultural workers thresh and mill their grain. Farmers plant and harvest root vegetables. Blacksmiths, basket makers and silk weavers ply their ancient trades.

Next, Passet intended to venture further than Kahn and Dutertre, by gaining entry to Mongolia. He wanted to visit the capital, Ulan Bator, but as he was about to depart, French consular officials warned against the plan. This fearless *opérateur*, however, was undeterred. In a letter to Albert Kahn dated 24 July 1912, Passet provided a colourful account of his Mongolian adventures:

I was determined to bring you back something from Mongolia, and despite the difficulties of travelling in a country without roads, I was lucky enough to encounter five Mongol villages where I found these really interesting nomads.... I was received in each village... by the chief who invited me into his tent. I had to sit on the ground, legs folded beneath me, and drink 'koumis' – a horribly bitter, sickly liquor made of fermented mare's milk. I managed to overcome my disgust and so thankfully was able to take pictures of tents, men and women. The women didn't want their picture taken, but they were ordered to by the chief, who did everything he could to make me happy. These Mongols have a fierce pride not found among the Chinese – it was impossible to offer them anything in return, and it would have angered them to insist.

▲ Punishment, Mongolian-style. This man, photographed on 24 July 1913, suffers the humiliation of wearing a wooden board around his neck, marked with a description of his crime for all to see. A3972 Stéphane Passet

Mysteriously, Passet spent just four days travelling in Mongolia, and then left Asia. He completed important assignments in the Balkans and Morocco before returning to Mongolia in the summer of 1913. On his second visit, Passet had sufficient time to produce a probing and powerfully intimate pictorial

record of nomadic Mongol life. In a delightful medley of films and autochromes, Passet observed the subtle and intricate forces at work in Mongolian society. His films show aggressive displays of masculinity in the country's most popular competitive sport: wrestling. He produced some striking images of hunters, still using prized but ancient matchlock rifles. Frequently, Passet's autochromes encapsulate the nuances of Mongolia's social hierarchies, written into the dazzling colour schemes found in the national dress.

There are entrancing images shot inside the country's Buddhist monasteries that were home to around one in five of all Mongolian men. But perhaps Passet's most memorable pictures are those that offer an unsettling glimpse into Mongolia's approach to criminal justice – methods of punishment that humiliated wrongdoers, yet still allowed this nomadic society to move its prisoners when it was necessary to do so.

This talented and indefatigable *opérateur* had hoped to include Japan on his Asian itinerary. For reasons that remain unclear, regrettably – for the Kahn Archives in particular as well as for posterity in general – this leg of his odyssey never came to pass. Instead, in December 1913 Passet did reach a symbolically important place in another of the continent's ancient cultures.

Rising proudly over the west bank of the River Ganges, Varanasi is one of the most sacred cities in the Hindu tradition. Every year, thousands of pilgrims descend on the city to bathe in waters that are considered particularly auspicious. On riverside terraces known as ghats, the faithful cremate the bodies of the deceased before pouring their ashes into the Ganges. The bereaved feel assured that they could not

▼ Terraced steps known as ghats line the banks of the Ganges at Varanasi, seen here in January 1914. One of the world's oldest continuously inhabited cities, Varanasi is still a place of pilgrimage for many Hindus. A4436 Stéphane Passet

▲ This dreadlocked Hindu renunciate, photographed in Lahore on 11 January 1914, is covered in cremation ash, which symbolises the death and rebirth cycle central to Hindu belief. A4400 Stéphane Passet

Maria Misra has suggested, with the rise of Mahatma Gandhi – who also presented himself as a religious mendicant with a moral and political message – these holy men would eventually be drawn into the non-violent, anti-colonial movement that destabilised British rule in India and eventually demolished the Raj. If he had sensed this prospect, it is unlikely that Passet would have mourned the passing of British rule. Few of his pictures reflect the colonial presence; and when he directly encountered India's British overlords, his experience was an unhappy one.

have chosen a better resting-place for the remains of a devout Hindu.

As his films and autochromes so eloquently attest, Passet's interest in India was intense and his gaze was insistent: India enthrals, mystifies and beguiles him. Clearly, he was especially fascinated by India's wandering religious mendicants: several autochromes feature the dreadlocked renunciates who divorced themselves from the material world and participated in extreme (indeed, sometimes scandalous) devotional rituals and sexual practices. As the historian

In January 1914 Passet headed northwest towards the Khyber Pass, that long, dangerous, strategically sensitive conduit that today links Pakistan to Afghanistan. Within the Pass lived the clansmen of the Afridi. Mainly Muslims, and belonging to the Pashtun people of the region, the Afridi possessed a proud warrior tradition and had largely resisted the impositions of British rule. Hoping to capture a flavour of their rich and distinctive culture, Passet sought permission from the Raj administrators to enter the Pass; but his request was flatly denied. In a letter to Jean Brunhes dated 19 January 1914, the cantankerous photographer did little to disguise his contempt for those who had thwarted his ambitions.

THE FAR EAST

193

The English are savages, and the first impression I had in Bombay has now been confirmed here. I was thought to be a spy or a criminal – I provoked nothing but suspicion. Anyone else who comes here is allowed to visit the Khyber Pass, but I wasn't allowed anywhere near. I was kept some 15 kilometres [10 miles] away. I asked the authorities why this was, having presented them with my papers, emphasising the fact that I wanted to go to Afghanistan to see certain villages. All my requests were immediately declined. I had taken two railway trips in 24 hours with all my equipment, only to be sent back empty-handed.

Vendors selling horses or renting cars refused to sell or rent to me, so that I could leave this English town, and the Governor let me know that if I tried, I would be expelled and escorted back to the military base. This is charming.... These people haven't even gone to the trouble of properly reading the letters that I have given them; they remain as frosty and stiff as their starched collars. They are imbeciles, ridiculous and uncultured. I apologise for the tone of my letter, but this expresses only a fraction of my thoughts.

Eventually, by taking a circuitous route, Passet overcame all these obstructions and filmed a glorious sequence of Afridi children performing their splendidly energetic dance. Passet had triumphed over the intransigence and hostility of the British. The next time one of Albert Kahn's photographers visited India, officialdom would give him a very different reception from the one accorded to Passet.

In 1927, the cinematographer and *autochromiste* Roger Dumas (1891–1972) undertook what would be the Archives of the Planet's final excursion to India. He had arrived there after visiting Japan, where he had filmed and photographed a nation in mourning: over a million people gathered in the centre of Tokyo to bid goodbye to the figure known in the West as Emperor Yoshihito following his death on Christmas Day, 1926. The palpably sombre mood visible in the films Dumas shot in Japan stands in contrast to the celebratory atmosphere evident in his images of India, where the *opérateur* had been granted access to the lavish festivities marking the golden jubilee of the Maharajah of Kapurthala, Jagatjit Singh.

An acquaintance of Albert Kahn, the Maharajah had visited him at his Boulogne-Billancourt residence in June 1923. In terms of their personal lives, the two men stood at opposite poles: while Kahn remained a lifelong bachelor, Jagatjit was married six times (including one particularly scandalous union with a Spanish flamenco dancer, Anita Delgado). But the men also had much in common. Both were rich; they had an interest in international affairs; and they shared a deep affection for French culture. Jagatjit expressed this admiration by turning Kapurthala into what some called 'The Paris of the Punjab'. He commissioned French architects to develop an ambitious reconstruction programme that would transform a relatively nondescript Indian backwater into a town studded with buildings loosely modelled on Fontainebleau and Versailles.

While Passet's experience in the Raj had been a litany of ire-inducing frustrations, Dumas seems to have enjoyed unfettered access to the Maharajah and his illustrious circle of Indian aristocrats – many of whom gathered in Kapurthala for the jubilee. Dumas manoeuvred his cameras in front of some of the most powerful men in India, including the recently appointed Viceroy, Lord Irwin. Little more than ten years later, Irwin – who by then was known as Viscount Halifax, and was the British Foreign Secretary – would be a vociferous champion of the disastrous policy of appeasing the territorial aggressions of Nazi Germany. But between 1926 and 1931, when he was faced with a Gandhi-led non-violent resistance movement striving for national self-determination, Irwin had fewer qualms about using force to counter threats to the existing order. Among other coercions applied during Irwin's period in office, martial law was imposed and around fifty thousand people were imprisoned for breaching the iniquitous laws protecting the Raj's monopoly on salt.

In Kahn's autochromes of the Kapurthala jubilee there are few visual clues hinting at the corrosive political forces that were already undermining

▲ The Viceroy Lord Irwin and his wife flank the Maharajah of Kapurthala, Jagatjit Singh, on the occasion of his golden jubilee in November 1927. A59290 Roger Dumas

the authority and prestige of both Irwin and the Maharajahs. But Dumas' films of duck shoots and elephant processions, of Nawabs hobnobbing with Viceroys and of Maharajahs being weighed in silver bars, would be among the first (and the last) images of a social and political hierarchy *in extremis*. By 1947, the power of both the Maharajahs and the British Raj would be relinquished for ever. Although he could not know it, Dumas produced a set of autochromes that had embalmed a colonial body politic that was already withering away.

Japan c. August 1912
Here, the leading actor in the Noh play *Mochizuki* is performing the Japanese *shishi-mai* or lion dance. Noh theatre dates back to the fourteenth century and remains a living art form in Japan. At the National Noh Theatre in Tokyo, performers still play to packed houses. A6591 Stéphane Passet

▶ **Kyoto, Japan** c. August 1912
In the former Japanese capital of Kyoto, two geishas clasp hands with a young maiko, or apprentice geisha. Most maiko girls faced five years of training in dancing, singing and musicianship before they were considered fully-fledged geishas. In the 1920s there were around 80,000 geishas in Japan: it is estimated that there are just 10,000 practising the art today.
A6600 (detail) Stéphane Passet

Takanawa, Japan 1926 or 1927

Pictured in the grounds of the family palace in Takanawa (now part of Tokyo) is Kahn's old friend Princess Fusako Kitashirakawa. On her right, sitting above her daughter Taeko, is Prince Chichibu, the brother of the heir to Japan's imperial Chrysanthemum Throne, Prince Hirohito (who became Emperor in 1927); and to her left is her son Prince Nagahisa, who died in an aeroplane crash in 1940.

A68635X Roger Dumas

Japan 1926 or 1927
In mid-1920s' Japan, this young woman would have been known as a 'moga', short for 'modan gaaru' or 'modern girl'. She may be wearing a traditional Japanese *yukata* dress, but there is nothing traditional about her choice of hairstyle: she has adopted the bob cut that was the height of fashion among flappers in the West. A68876 Roger Dumas

Peking, China 29 June 1912
Built by Emperor Qianlong in 1755, the original Qinqyanfang (Boat of Serenity) was constructed out of marble to symbolise the enduring power of the Qing dynasty. Although it was destroyed by French and British troops in 1860, it was rebuilt, again in marble, but in a new, Westernised design – a pastiche of a Mississippi paddle steamer. A572 Stéphane Passet

Inner Mongolia, China 18 July 1912
At an encampment in Inner Mongolia some of these men and women are wearing the traditional long Mongol robe known as the *deel*. The man on the far left seems to be barefoot, so he is probably a servant. On the roof of one of the yurts behind the group a cheese has been left out to dry. A763 Stéphane Passet

Peking, China 26 May 1913

Although the identity of this man has not been recorded, his elaborate robes and head-dress suggest that he is an officiating lama (Buddhist priest), who would have been responsible for overseeing important Buddhist ceremonies, including funeral cremations.

A3995 Stéphane Passet

Peking, China 23 June 1912

The man on this bridge is wearing the traditional ponytail, known as the *queue*. The new Chinese Republic, which came to power in 1912, revoked the Manchu-era law that made the *queue* compulsory. When it was originally imposed on the Han Chinese in the seventeenth century, non-compliance was punishable by death. A720 Stéphane Passet

Nankou, China 19 July 1912
The Great Wall of China took more than 1000 years to build. It is 4160 miles long and in terms of mass is the largest man-made object ever constructed. Passet's picture is taken from Nankou – the same place that Kahn and Dutertre had visited during their round-the-world trip of 1908–9. A731 Stéphane Passet

Shenyang, China May or June 1912
This is a street of jewellers in the city of Shenyang in northeast China. Also known by its Manchu name, Mukden, the city was invaded by Japanese troops in September 1931 – a military prelude to Japan's occupation of the whole of the Chinese province of Manchuria, which would be completed by the end of the year. A70101X Stéphane Passet

Shenyang, China 1913
These men are using China's traditional – and very laborious – method of stone-cutting. This monolith would probably have been turned into an engraved stele and used either as a tombstone or a commemorative obelisk. A5487 Stéphane Passet

Nanyuan, China 25 May–27 June 1913
The pith-helmeted figure with his arms behind his back is the French aviation pioneer René Caudron. In this photograph he is standing in front of a Caudron G-2 biplane, which he designed, at the soon-to-open Nanyuan aerodrome – China's first training school for would-be aviators. A68607 Stéphane Passet

Shenyang, China May 1912

Behind these boys are the imposing city walls surrounding Shenyang, capital of Liaoning Province in northeast China. Built in the eighteenth century, these huge fortifications were demolished after Mao Zedong proclaimed the creation of the People's Republic of China in October 1949.

A765 Stéphane Passet

Qufu, China 14 June 1913
This young man is leaning against a column in the temple complex of Kong Miao at Qufu in the province of Shandong. One of the largest architectural heritage sites in China – second in size only to the Forbidden City – Kong Miao is the temple dedicated to the great sage Confucius, who was born at a house on this site in 551 BC. A1273 Stéphane Passet

Ourga, Mongolia 21 July 1913
These lamas have gathered outside a line of stupas in a monastery at Ourga, near the present-day capital of Ulan Bator. Inside these buildings, the faithful would turn prayer mills, upon which Buddhist texts were inscribed. A3979 Stéphane Passet

Ourga, Mongolia 24 July 1913
Decked in his remarkable golden finery, this is the Grand Lama, the most important figure in Mongolia's Buddhist hierarchy. In the year this picture was taken, Mongolia had declared itself an independent theocratic state, a development that conferred great powers on the leading Buddhist priests. A3967 Stéphane Passet

▶ **Ourga, Mongolia** 23 July 1913
This is the Princess of the Khalkha Mongols, a sub-group that was in the vanguard of Mongolia's independence movement at this time. She is wearing the traditional costume of a noblewoman. Her elevated social position is denoted by her silver jewellery and the gems adorning her elaborate head-dress, known as a *boqtaq*. A3962 (detail) Stéphane Passet

Ourga, Mongolia 20 July 1913
These tents are known to the Mongolian people as *gers*, though they are perhaps better known in the West as yurts. Made from felt draped on a wooden lattice frame, they could be dismantled and rebuilt in just half an hour, making them ideal dwellings for the nomadic herdsmen of the Mongolian steppes. A3959 Stéphane Passet

Mongolia 20 July 1913

At the time of Passet's visit, the itinerant hunters of Mongolia were still using matchlock rifles to hunt their prey. It is likely that this man, who appears to be near Mongolia's border with Russia, would have made a living by selling the pelts of foxes and wolves.

A3948 Stéphane Passet

THE FAR EAST

Ourga, Mongolia 25 July 1913
In this distressing autochrome, a female Mongolian prisoner struggles to free herself from a crate in the Ourga region. Although Stéphane Passet believed she had been incarcerated for committing adultery, Mongolian society had a relatively relaxed attitude towards matters of sexual morality at this time, so it is probable that she had been convicted of a more serious crime. A3973 Stéphane Passet

Ourga, Mongolia 25 July 1913

In Mongolia's criminal justice system, methods of punishment were adapted to meet the needs of a nomadic society. As we can see here, wrongdoers might find themselves locked into heavy chains; such measures prevented escape attempts, yet enabled the Mongols to take their prisoners with them as they migrated across the steppes.

A3971 Stéphane Passet

Ahmedabad, India 20 December 1913
The man in the foreground of this picture, which was taken at the Jain temple of Hathi Singh in Ahmedabad, is probably a Brahmin; behind him stands a Jain monk of the *svetambara* tradition, whose adherents always wear white clothes.

A4176 Stéphane Passet

Agra, India 29 December 1913
Most visitors to Agra train their cameras on its most celebrated monuments, especially the peerless, glittering Taj Mahal. Here Passet captures the life of the city at its most quotidian – yet his century-old images of ordinary streets and ordinary people seem just as extraordinary and precious as his shots of the world-famous landmarks near by.

A4341 Stéphane Passet

Delhi, India 23 January 1914
Passet timed his visit to Delhi's Jama Masjid to coincide with the vast congregation that regularly turned up for Friday prayers. Built by the Moghul Emperor Shah Jahan and completed in 1656, the Jama Masjid is still one of the largest mosques in India: it can hold 25,000 worshippers in its courtyard alone. A70601 Stéphane Passet

Bombay, India 16 December 1913
Throughout his journey across India, Passet produced many fine studies of religious observance. In Bombay, now known as Mumbai, he photographed this sadhu (holy man) reading passages from a sacred Hindu text. A4367 Stéphane Passet

Bombay, India 17 December 1913
This striking picture shows a quintet of wandering sadhus in Bombay. Unlike monks in the Christian tradition, Hinduism's holy men tended to live outside monasteries, many of them in forests or caves. It is estimated that up to 4 million Indians still live the ascetic lifestyle of the sadhu today.

A4370 Stéphane Passet

Agra, India 25–27 December 1913
Constructed between 1632 and 1648, the Taj Mahal was Shah Jahan's mausoleum for his beloved wife Mumtaz, who had died in childbirth in 1631. Over the years it fell into disrepair, but in 1908 builders completed the restoration programme ordered by the Viceroy, Lord Curzon. Passet's autochrome is among the earliest-known colour photographs of India's most famous monument. A4252 Stéphane Passet

Kapurthala, India November or December 1927
In India, cows have been used both as a means of transport and as beasts of burden for centuries, and this remains so across much of the country today. Revered by Hindus, they occupy a unique status: in some Indian states, to kill a cow is a crime punishable by up to ten years in prison.
A59389 Roger Dumas

Kapurthala, India November 1927
As part of the celebrations during the Maharajah of Kapurthala's golden jubilee, the terrace of his palace was converted into a prayer room for the Hindu ceremony of puja. Eventually, after he had been weighed on a scale, the Maharajah's weight in gold, silver and food would have been distributed to the poor. A59289 Roger Dumas

Kapurthala, India November 1927
The cream of India's aristocracy gathered to celebrate the golden jubilee of the Maharajah of Kapurthala, Jagatjit Singh. He entertained his illustrious visitors from India's princely states by staging tiger hunts and elephant processions. Yet despite their ostentatious clothes and lavish displays, India's former rulers had no power to control their own destiny.

A59293 Roger Dumas

Delhi, India 7 January 1914
A group of Hindu mourners attend a cremation ceremony near Delhi, which the British administration had turned into India's new capital city in 1912. According to Stéphane Passet, dried cowpats were used to fuel the funeral pyre, which suggests that the deceased was not from a well-off family, since the wealthy tended to use wood.
A69587X Stéphane Passet

Colombo, Ceylon 22 July 1914
A fruit-seller offers her produce in the Sri Lankan capital, Colombo. At the time of Léon Busy's visit, the island was known as Ceylon, and was still part of the British Raj. The island was a Crown Colony for almost 150 years before it finally achieved independence in 1948. A5082 Léon Busy

6 Indochina

At Marseilles, on Sunday, 12 July 1914, a French army officer named Léon Busy (1874–1950) boarded a ship bound for Hanoi, the capital of French Indochina. The journey would allow Busy to renew his acquaintance with a land he knew well. On four previous postings, he had been sent to what the French Republic considered its *Perle de l'Extrême-Orient*. He did not know it, but Busy was embarking on his fifth visit less than a month before the German invasion that would leave his homeland imperilled and at war.

Just a few weeks before his departure, Busy had sent a letter to Jean Brunhes. In it, he volunteered to take pictures for the Archives of the Planet during his forthcoming stay in Indochina. Referring to his familiarity with the country, Busy mentioned that in the most recent competition organised by the prestigious Société Française de Photographie, he had been awarded first prize for his colour photography. Brunhes' response to this letter has not survived, but he was sufficiently impressed to take up Busy's offer. In aesthetic terms, Brunhes' decision would prove to be particularly judicious. During the next two and half years, Busy would provide some of the most ravishing images ever delivered to the Kahn Archives.

Busy arrived in Hanoi at a time when most of the human traffic between France and its primary Asian colony was travelling in the opposite direction.

▲ Seen here in his army uniform, Léon Busy shot some of the Kahn collection's finest images. CB911 Léon Busy

◀ These girls are human chess pieces. The game was played during festivals and holidays, and it was an honour to be chosen to appear on the board. A10395 (detail) Léon Busy

Between 1914 and 1918, around a hundred thousand personnel (roughly half civilian workers, half conscripts) were sent to France to support the war effort. Thousands fought in some of the war's bloodiest confrontations, including the Somme. But at the same

▲ This paraphernalia was used for smoking opium. In Vietnam it was a ritualised social indulgence, often taking place for hours in the company of close friends. A6668 Léon Busy

time that these Vietnamese soldiers were dying for France, increasing numbers of their countrymen were trying to bring down the French colonial enterprise altogether.

French Indochina had been created following a complex sequence of events in the nineteenth century. In the late 1850s, after attacks on Catholic missionaries in the region, the French Emperor Napoleon III launched a punitive naval expedition, and by 1859 his forces had seized the cities of Da Nang and Saigon. By 1867, the French ruled much of what they called Cochinchina – today an area that lies in southern Vietnam. Over the years that followed, the Europeans moved north, establishing control of the remainder of the country, which they administered as two separate protectorates: Tonkin in the north and, in Vietnam's central belt, Annam.

After disposing of Chinese claims to Vietnam by winning the Sino-French War of 1884–5, France added Cambodia (1887) and Laos (1893) to complete their Confédération Indochinoise. As usual in the nineteenth-century colonial story, resistance was met by a force not overly encumbered by moral principle or human decency. Insurgencies, often led by members of Vietnam's educated mandarin class, were common throughout the period; generally they were crushed without compunction. Many of those who dared to strive for independence would meet their end courtesy of the French administration's guillotine, or the French infantryman's bullet.

Several significant rebellions occurred in Vietnam while Busy was busily producing autochromes for Kahn. The February 1916 seizure of a prison by rebels in Saigon, and the attempted coup by Vietnamese soldiers (endorsed by the country's titular boy-Emperor, Duy Tân) three months later in Hanoi, are just two episodes in a period marked by intermittent anti-French agitation. This unrest received extra impetus from widespread resentment at the increasingly

exploitative character of French rule. Vietnamese grievances extended from an unfair tax regime (the French exempted themselves completely from contributions) to state monopolies in a range of goods from agricultural products to salt, alcohol and, most outrageously of all, opium.

It is unlikely, though by no means impossible, that Busy would have witnessed the worst aggressions of his fellow Frenchmen. Holding the rank of *sous-intendant-militaire*, Busy was effectively a quartermaster, and his primary responsibilities would have resided in the area of logistics and supply. Details of his experience in the colonial service are scant, but it seems safe to assume that, given the option, Busy was far more enthusiastic about the idea of shooting his autochromes than shooting 'the natives'.

In fact, Indochina's French squatters seldom trespass in front of Busy's lens. But a few of his pictures do illuminate the means by which his countrymen were progressively transforming Indochina. In his cityscapes of Hanoi, French colonial terraces recede down broad, Gallic-looking boulevards. His autochromes also feature the giant Paul Doumer Bridge that the French built over the Red River, a construction that the writer and academic Georges Boudarel has described as 'a colonial answer to the Eiffel Tower'.

Busy's attentions were more frequently distracted by the dress, working lives, leisure activities, religious practices, gastronomic conventions and social hierarchies of Vietnam and its people. Encompassing every level of the social spectrum, his images distil moments from the daily lives of farmers and fisherwomen, priestesses and wrestlers, beggars and lepers, actors and musicians. But of all Busy's observations of the people of Vietnam, it is his study of the country's women that is both the most eye-catching and the most contentious.

As is evident in most of his images, Busy's cameras tended to linger disproportionately on the feminine presence in Indochinese life. In what is, in the context of the Archives of the Planet at least, a very unusual

▼ Designed by Gustave Eiffel and completed in 1902, the Paul Doumer Bridge (now known as Long Bien Bridge), was bombed repeatedly during the Vietnam War. A6632 Léon Busy (1915)

pictorial serenade to womanhood, he shot a long series of autochromes that closely observe a young girl progressively shelling and eating a betel nut; and, in some of the most controversial footage produced for the Archives of the Planet, Busy filmed an adolescent girl divesting herself of successive layers of clothing until she reaches a state of total undress. Decorously, Busy grants his young subject a modicum of modesty by shooting the scene out of focus. Nonetheless, as the film historian Sam Rohdie observes:

Looking at many of Busy's autochromes, especially of Vietnamese girls and women, it is difficult to see their documentary, scientific function for the presence in them of sensuality and eroticism, that is, of desire, emotion, response, feeling and the care that was exercised to these ends in lighting, framing and posing. Some of his images duplicate paintings or are unashamedly painterly and expressive. The best are very beautiful, the worst merely vulgar.

As well as being accused of prurience and voyeurism, Busy's oeuvre has been seen as representative of what some call 'the colonial way of seeing'. Certainly, set against the scarce pictorial references to the French, Busy's depictions of the Vietnamese people are conspicuously explicit and invasive. This has prompted another film historian, Paula Amad, to describe his work as 'some of the most aesthetically stylised and politically muted films in the archive'.

Why do Busy's pictures fail to address head-on the routine brutalities of colonial life? Was it because, as Amad suggests, the Archives of the Planet were 'an unofficial ambassador for French colonial policy'? Did Kahn or Brunhes order him to refrain from recording anything that might jeopardise the Archives' cordial relationship with the higher circles of the French military? Was Busy prevented from shooting the activities of the French army by

▶ Léon Busy photographed this blind beggar pleading for alms from passers-by in Tonkin in 1914. At that time French colonials were exempted from a pernicious tax system that helped to make many Vietnamese people destitute. A5219

the diktat of a senior officer? Was it simply self-censorship, or a matter of taste?

We may never know precisely why Busy's photography is so sensitive and articulate on some matters, yet so blithely silent on others. What is indisputable, however, is Busy's technical virtuosity. The 1089 autochromes he produced during his thirty-one-month period working for Kahn in Vietnam attest to the nonpareil sophistication of his eye and his mastery of the photographic craft. To some of the shrewdest observers acquainted with the Archives in their entirety, Busy was the finest and most accomplished *autochromiste* ever employed by Albert Kahn.

Léon Busy left Vietnam on 11 February 1917. After undertaking further missions for the Archives to Bulgaria, Turkey and Greece, in 1921 he returned to Indochina to visit one of the most important monuments in the world. Recently, satellite surveillance of the glorious temple complex at Angkor has established that in the pre-industrial period it was part of the biggest city on the planet. Built between the ninth and the fifteenth centuries, it stretched across an area of more than 1000 square miles – twenty times the size of its nearest competitor, the city of Tikal, in Mayan-era Guatemala. Today, these architectural masterpieces from the golden age of Khmer civilisation are visited by around a million tourists a year. By contrast, when Busy shot his films and autochromes Angkor was all but deserted: the few people he glimpsed through his camera were either the dancers of the Cambodian Royal Ballet or beggars hoping for alms from the few French colonials and Buddhist pilgrims who had ventured there. Throughout, Busy's cameras address these gorgeous monuments with a loving gaze: no wonder that for many of those who have subjected Kahn's autochromes to close scrutiny it is Busy's oeuvre that impresses itself most insistently on the mind.

Like the Vietnamese, the people of Cambodia had by then made little secret of their discontent with the French colonial apparatus. In 1916, hundreds of people from the countryside were arrested after they descended on Phnom Penh to protest against French fiscal policies and the imposition of forced labour. There is no hint of this in Busy's films and photographs. He was a craftsman par excellence in the use of autochrome, but his images impose a romantic glamour on the cruel yet strangely theatrical business that was French imperial rule.

Following intense resistance over several decades that culminated in the Battle of Dien Bien Phu in 1954, the French finally relinquished their control of Indochina – although, of course, the malign effects of outside interference in Vietnamese and Cambodian affairs did not end there. Millions more lives would be lost in the Vietnam War (1965–73) and the consequent catastrophe that befell Cambodia during the genocidal rule of the Khmer Rouge under the demented leadership of Pol Pot. As the twentieth century unfolded, both countries discovered that resting at one of the pressure points of superpower rivalries was a lethal place to be.

Vietnam 1914–18

In Vietnam water buffalo played a vital role in the cultivation of rice. Not only were they used to pull ploughs over the fields before planting, their dung also fertilised the crop. Here a girl is leading a buffalo through the paddy: in most families this duty would have fallen to the boys. A10380 Léon Busy

Zhanjiang, Vietnam 1914 or 1915
In 1898 France occupied the fishing village of Zhanjiang, where this young woman is paddling. Renamed Fort Bayard, it was seized by Japan in 1943. Now in China, Zhanjiang is home to many surface ships in the People's Republic's South Seas fleet. At the time when this photograph was taken, there was no hint that these serene waters would become one of Asia's most important naval bases.
A5295 Léon Busy

Vietnam May 1915
Resplendent in blue, the chief of this canton poses alongside fellow members of the local authority in front of a temple dedicated to the *génie du village* – the spirit that was thought to protect the community. Unfortunately, the exact location of this photograph was not recorded. A5532 Léon Busy

Hanoi, Vietnam July or August 1915
For centuries, smoking has been one of Vietnam's favourite vices. Like these men, many used long, thin tobacco pipes, usually made from bamboo. Today most smokers prefer cigarettes, but however it is consumed, tobacco remains immensely popular. Recent surveys suggest that 73 per cent of Vietnamese men smoke – the highest prevalence of male smokers anywhere in the world. A6674 Léon Busy

Tonkin, Vietnam December 1914
In Indochina during this period, people suffering from leprosy were often cared for by French nuns working at the country's Catholic missions. The sisters may have granted their fellow countryman permission to photograph this group of lepers, who were found by Busy in Tonkin. A5554 Léon Busy

Dông Dang, Vietnam September–November 1915
All appears sedate in this picturesque autochrome of Dông Dang near the Chinese border. But in the years ahead its people would experience great upheavals, including a traumatic invasion by 20,000 Japanese troops in 1940, the destruction of its rail links with Hanoi by American bombers in the Vietnam War, and the unwelcome arrival of three Chinese army divisions in the 1979 Sino-Vietnamese War.
A7363X Léon Busy

Hanoi, Vietnam February 1915
Vietnam's most important annual event is the Têt festival, which celebrates the start of the lunar new year. Here Busy focuses on calligraphers who are using Chinese ideograms – at a time when most literate Vietnamese people had adopted the Latin alphabet – to produce scrolls commenting on recent developments in Vietnamese culture and society.
A6617 Léon Busy

Hanoi, Vietnam 1914–16
Today over 90 per cent of Vietnam's people are literate, but under French rule many had no choice but to hire highly venerated scribes to compose letters and draft contracts. By the fifteenth century Han Chinese characters were replaced with the Nôm script, which appears on this document. Eventually, this too was supplanted by the Latin-based Quôc-Ngũ system, which is now Vietnam's official script.
A7302 Léon Busy

Vietnam September–November 1915
Under Vietnam's Confucian system, men such as these mandarin civil servants exercised powers delegated by the emperor to control civic and religious functions, military institutions and the legal system. There were nine grades in the mandarin hierarchy: here the relative seniority of the seated figure is evident by the generous embroidery on his robes. His rank would have been recorded on the horn he is holding in his hand. A70522X Léon Busy

▶ **Saigon, Vietnam** September–November 1915
Seen here in full costume, these actors are members of the company at the Saigon Theatre. During this period, theatre was a flourishing art form in Vietnam. In the south performers and dramatists developed a musical comedy genre called *cai luong* (renewed opera), which soon became more popular than the more classical *hat tuong* form of Vietnamese opera.
A7299 (detail) Léon Busy

Vietnam July or August 1915
Lying on a raised dais, this woman may have been the concubine of an affluent opium smoker. Most ordinary people consumed opium in dens, known as *fuméries*. The French operated a lucrative monopoly in opium distribution: some estimates suggest that a third of all colonial revenue was derived from the drug until the monopoly was dismantled in the 1930s.
A6670 Léon Busy

Vietnam May or June 1916
This woman is a priestess in the Taoist Three Worlds sect. Believers would have viewed her as a medium, possessing powers to communicate with the divinities of the three material worlds – the Celestial (skies), Terrestrial (earth) and Aquatic (seas). Unusually, this sect made the right to serve as a medium the sole preserve of women A9889 Léon Busy

Lung Vai, Vietnam September 1916
Gathered outside their home in the village of Lung Vai near the Chinese border is this family of ethnic Tàys. Vietnam's fifty ethnic minorities together constitute around 13 per cent of the population. Numbering an estimated 1.5 million people, the Tàys are the second-largest ethnic group in Vietnam. A9937 Léon Busy

Haiphong, Vietnam April or May 1916
Here farmers are engaged in the back-breaking task of transplanting rice seedlings in a paddy field near Haiphong, 60 miles from Hanoi. After a month growing in a seed bed, the young plants would be plucked by hand and reinserted into fields flooded either by rainwater or irrigation canals. Rice remains the great staple of Vietnam, which is now the world's fifth largest producer of the crop. A9946 Léon Busy

Tonkin, Vietnam 1914 or 1915
A young fisherman adjusts his net on the banks of a muddy waterway in northern Vietnam. Busy shot numerous films and autochromes of fishing practices; he was especially fascinated by the people who fished for crabs in the waters of Tonkin.
A5190 Léon Busy

Hanoi, Vietnam September–November 1915
It was once widely believed that the brittleness of kapok made it impossible to spin into yarn, but this production line near Hanoi appears to have overcome the limitations of the fibre. Made from the floss surrounding the seeds of the giant kapok tree, the product is still used throughout the Far East in the manufacture of pillows and quilts. A7368 Léon Busy

Hanoi, Vietnam September–November 1915
Sitting in the interior courtyard of a house are these children from a relatively prosperous family in Hanoi. While the sons of affluent parents would be sent to local schools – and later, possibly, to more advanced seats of learning in France – their sisters were afforded no such opportunities in French Indochina.
A7284 Léon Busy

Halong Bay, Vietnam January 1916
A sampan is moored on one of the 3000 islands in Halong Bay. The French were enchanted by the Halong archipelago: in the background of this autochrome lies an island containing Le Cirque de la Surprise – a wonderland of caves and grottoes that was designated a World Heritage site by UNESCO in 1994. A5599 Léon Busy

Vietnam c. 1921
Girls indulge in an ancient Vietnamese ritual: sharing betel nuts. For centuries betel has been offered in ceremonies and as a welcoming gesture to guests. Many believed that the nuts had a wealth of medicinal benefits, including the power to prevent tooth decay and cure sore throats and coughs. Although betels still feature in wedding ceremonies, few young people chew them today. A35953 Léon Busy

Xa La, Vietnam May or June 1916
Cock-fighting has been practised in Vietnam for at least 700 years. As well as staging special competitions during the annual Têt Festival, Vietnam's cock-fighters regularly test the fighting prowess of their birds at pits all over the country, where small-stakes gambling takes place.
A9886 Léon Busy

Vietnam 1914–18
Sporting the extravagant, flat-topped *nón quai thao* head-dress, this elegant young woman is wearing a pink *ao dai* tunic. In Vietnam, certain colours symbolise different emotions. Like red, the colour pink denotes good luck and happiness, as does the girl's broad smile – an expression which also reveals that in keeping with the fashion of the time, she has black lacquered teeth. A10334 Léon Busy

Tonkin, Vietnam February 1915
In a series of autochromes shot in northern Vietnam, Busy records male participants preparing to take part in one of Vietnam's most important martial arts: wrestling. Here the combatants' gesture is part of a ritualised homage to the spirits. A5566 Léon Busy

◀ **Hanoi, Vietnam** September–November 1915
These men are probably porters from Hanoi, who were part of the funeral cortège of an important local dignitary or mandarin. It would have been their duty to pull mourners sitting in rickshaws, and to carry the accoutrements required for a traditional Buddhist funeral ceremony. A7312 (detail) Léon Busy

Hanoi, Vietnam September–November 1915
Joining the funeral procession for the same grand mandarin was a group of musicians. The player on the left is strumming the traditional Vietnamese *dan nguyet*, or moon lute, so named because of its shape. A7311 Léon Busy

Angkor, Cambodia 1918 or 1921
Constructed in the twelfth century, when the Khmer Empire was at the height of its powers, the magnificent Angkor Wat temple in northern Cambodia is the most famous building in this 77-square-mile complex. Captured in an age when it took weeks for Westerners to travel to Indochina, Busy's autochrome is among the earliest-known colour photographs of this world-famous monument. A35852 Léon Busy

Angkor, Cambodia 1918 or 1921
Near the moat encircling Angkor Wat are the dancers who perform in the Khmer ballet. They are the living embodiments of Angkor's *apsaras*, the exquisite dancing nymphs that are carved on stone pillars and adorn the temple walls. Classical Khmer dance was almost eradicated during the genocidal rule of the Khmer Rouge, but the tradition has enjoyed a renaissance in recent years.
A36050 Léon Busy

7 The Middle East

In the years 1918–19, when Albert Kahn's photographers first planted their tripods in the sands of the countries we now know as Saudi Arabia, Lebanon, Syria, Jordan and Israel/Palestine, the region was known as the Levant. The term 'Middle East' had only recently begun to replace it as a catch-all geographical term (the phrase was first used in 1902 by the American military strategist Alfred Mahan, who had coined it in a seminal article analysing British interests in the Persian Gulf). Before they had acquired their new regional identity, these lands had been provinces of the Ottoman Empire. But the empire's grip on its territories had weakened after an uprising by the so-called Young Turks in July 1908. This had restored parliamentary powers in Ottoman Turkey, and undermined the authority of the Sultan. Nationalists across the empire took the turbulence in Turkey as their cue. After the Ottomans relinquished their last remaining European lands in the 1912–13 Balkan Wars, those Arabs longing to control their own national destiny sensed that their moment too had arrived.

In 1916, when the Ottomans were facing the not insignificant additional distractions created by their participation in a world war, Arab nationalists rose up against their Turkish overlords. As part of their campaign, they helped the British forces who were

▲ In Tehran, Persia, three women pose in colourful and intricately embroidered hijabs. A52959 Frédéric Gadmer (1927)

◀ A Hashemite Arab boy rides through Antioch on 26 October 1921, just days after France granted the city special autonomous status within Syria. A29992 (detail) Frédéric Gadmer

ranged against Ottoman armies in the Eastern battlefields of the First World War. After defeating the Turks at Aqaba in July 1917, Arab fighters supported General Allenby's men during their successful attempt to take control of Jerusalem by Christmas. In September the following year, Arab forces were also instrumental in the Anglo-Arab victory in the Battle of Megiddo – a crucial confrontation that routed the Turkish army. This result eventually allowed British and Arab forces to wrench Amman,

▲ Seen here in Aqaba, Jordan, on 28 February 1918, Emir Faisal would soon become King of Syria. He would lose his crown there, but gain another in Iraq. A15488 Paul Castelnau

the most important city of what is now Jordan, from the Ottoman grip, and opened the way for them – in concert with Australian Light Horse Brigades and Indian Lancers – to take Syria's capital, Damascus. By then, one of Kahn's photographers had already stepped into the fray.

In the course of this pivotal year in Middle Eastern history, the accomplished *autochromiste* Paul Castelnau had journeyed through the countries that are now Egypt, Saudi Arabia, Israel, Palestine and Jordan. By 24 February he had arrived at the port of Aqaba, where he photographed Emir Faisal, the man who (alongside a certain T. E. Lawrence) had become one of the chief architects of the Arab Revolt.

A little over two years after Castelnau's encounter with Faisal, on 7 March 1920 the Emir attained a new title – that of King of Greater Syria. But his elevation was short-lived. Just a few weeks later, Faisal was removed from power after the League of Nations granted France – which had long had political influence in the area – mandated powers over Syria and Lebanon. Faisal no longer reigned in Damascus, but by 1921 he had the far from negligible consolation of being King of Iraq instead. He managed to hold on to his throne in Baghdad until his death in 1933.

Paul Castelnau's tour of the Middle East ended in December 1918, but Albert Kahn's representation in the region resumed the following year, when the photographer and cinematographer Frédéric Gadmer was dispatched to Syria and Lebanon. His visit coincided with the arrival of the distinguished one-armed war hero General Henri Gouraud, the man whom the French government had installed as governor of their newly acquired territories in the Levant.

For Gadmer – though not necessarily for the people of Syria and Lebanon – the imposition of the French mandate had several happy implications. Importantly, it allowed him to exploit Albert Kahn's well-established connections in the French political,

diplomatic and military hierarchies. Like Castelnau before him, Gadmer seems to have enjoyed privileged access to the military presence in the new French quasi-colonies of the Middle East.

Coming so soon after millions of French servicemen had seen action in a gruelling four-year war in Europe, it would be reasonable to expect to see little enthusiasm for a further tour of duty in the Middle East. But in the films that Gadmer shot in 1919, many French soldiers appear to be enjoying life in their new Levantine playground. Some of the most surprising ciné footage in the Kahn Archives, these films record troops cavorting with prostitutes outside a brothel in Beirut. In scenes that would be all but unthinkable today, the women pose brazenly for the camera, while their French clients prod bosoms and probe backsides with wanton glee.

At other times, Gadmer filmed scenes of joy occasioned for less lascivious reasons. One sequence, shot in 1919, shows British troops marching from Syria towards Beirut. In these pictures, their stride is coordinated, their demeanour purposeful and their mood jaunty. Endearingly, one Tommy spins his pith-helmet on the point of his bayonet in what seems to be a show of barely restrained exhilaration by a young man who realises that, against the odds, he has escaped death on a foreign field and may now be heading home at last.

Like Castelnau before him, Gadmer did not in any way consider himself confined to barracks. Throughout his visits to Syria and Lebanon in

▲ General Henri Gouraud (seen here on 3 October 1919) governed Syria after his forces imposed a French mandate. He lost an arm at Gallipoli in 1915. A19031 Auguste Léon

1919 and 1921, and his expedition to Iran, Iraq and Afghanistan in 1927–8, this gifted *opérateur* was anxious to preserve on his glass plates the cultural, geographical and architectural diversity of the people, communities and landscapes of the Middle East.

Although much of the region has undergone dramatic change since Gadmer filmed there, in some quarters life proceeds in much the same way as it

▲ A biblical scene in Lebanon in 1919. Many farmers have since abandoned their lands because of unexploded bombs dropped by Israeli warplanes in July 2006. A19803 Frédéric Gadmer

did almost a century ago. Then as now, the region contained many complex and dynamic cities, and boasted world-famous monuments, temples of immense grandeur and renowned seats of learning. Likewise, in the countryside, shepherds in traditional keffiyeh head-dresses still drive their flocks to lush oases as they did a century ago. It remains possible, also, to find Bedouins crossing the desert in caravans of dromedaries. But this is not a case of *plus ça change*. These apparent continuities veil the severe decline in Arabic rural and nomadic cultures.

It is estimated that a century ago, fewer than 10 per cent of the population of the region lived in cities. By 1970 that figure had risen to 40 per cent. Today, more than 80 per cent of the people of the Middle East are urban dwellers. In almost all parts of the region, rural and nomadic populations continue to dwindle, and their traditional pastoral, agricultural and migratory lifestyles are vanishing with them.

In what would be his final sojourn to the Middle East at Kahn's behest, in the summer of 1927, Gadmer headed for Persia and Iraq. By the autumn of that year, vast new oilfields would be discovered near Kirkuk. In the years that followed, the political destinies of these lands would be fundamentally reconfigured by an infernal cocktail of war, geopolitical manoeuvring by the superpowers, religious fundamentalism and nationalism, insurgency, revolution, ethnic strife, sectarian enmity, authoritarian one-party rule, tyranny, terrorism and, last but not least, the accursed bounty of oil. On film and in photographs, Kahn's *opérateurs* Paul Castelnau and Frédéric Gadmer filmed one Middle Eastern war and its aftermath; they could not know that a diabolical cycle of instability and violence would continue in an unbroken sequence for decades to come.

▶ These boys, photographed on 14 October 1921, are probably Druze from Qanawat, 60 miles from the Syrian capital, Damascus. In Roman times the city (then known as Kanata) was a significant trading hub. These youngsters are standing among its many ancient ruins. A29587 (detail) Frédéric Gadmer

Aleppo, Syria 23 October 1921
Bedouins weave fabrics on a traditional loom near the village of Marran, near Aleppo. Since the 1950s, a combination of drought and political pressure from states anxious to exploit Bedouin lands has forced many desert nomads to abandon their traditional lifestyle and settle in the cities. A29915 Frédéric Gadmer

Hama, Syria 22 October 1921
The long exposure times required for autochromes has blurred the movement of two of the seventeen giant water-wheels that were used to scoop water from the Orontes River near the city of Hama. Known as *noria*, these wheels, which are thought to be around a thousand years old, are up to 65 feet in diameter. A29861 Frédéric Gadmer

Beirut, Lebanon 22 November 1919

A senior officer stands in Beirut's main military barracks, the Grand Serail. In the mandate period, the Serail became the headquarters of the French Governor, and since independence has been used as the base for Lebanon's Prime Ministers. Although its Ottoman clock tower survives, much of the original building was demolished in 1998.

A19747 Frédéric Gadmer

The Bekaa Valley, Lebanon November 1919
This detachment of British troops is travelling between Beirut and Zahlé in the Bekaa Valley. At the post-war peace conference in Paris, France had won mandated powers over Syria and Lebanon, while Britain took control of Palestine, Jordan and Iraq. By November 1919, these British troops were preparing to relinquish their positions in Lebanon to the French. A19855 Frédéric Gadmer

Jerusalem, Palestine 3 August 1918
Today we associate Middle Eastern pipe-smoking with the large and ornate *shisha* or hookah. But in Jerusalem, Castelnau found this elderly woman (from the town of As Salt, in what is now Jordan) who had adopted a more readily portable option.
A15786 Paul Castelnau

Jerusalem, Palestine 2 August 1918
After the removal of the Ottomans from Jerusalem the previous December, the quality of life for people such as this Bedouin elder gradually improved. For one thing, food returned to the markets: during the war, Ottoman troops frequently requisitioned goods, so Palestine's farmers stopped growing food, and shopkeepers kept produce off their shelves.
A15785 Paul Castelnau

Bethlehem, Palestine 31 July 1918

The woman on the left of this trio of formidable Catholic matriarchs from Bethlehem is wearing the married woman's *shatweh* head-dress. Embroidered and ornamented with coins and coral, the *shatweh* is held in place by a silver chain chinstrap. Typically, the densely patterned *thob malak* (royal dress) that the same woman is wearing would be worn on ceremonial occasions, or at weddings.

A15772 Paul Castelnau

Aqaba, Jordan 28 February 1918

In June 1916, Emir Faisal's father, Hussein bin Ali, unleashed the Arab Revolt. With his brother Abdullah, Faisal led the attempt to wrest Arabia from the Ottoman grasp. At Aqaba, early in 1918, this corps has assembled to support Faisal's campaign. By September, these men would help Faisal to score a vital victory over the Ottomans at the Battle of Megiddo. A15491 Paul Castelnau

Aqaba, Jordan 28 March 1918
Finding shade in a glade at Aqaba are some of the 5000 warriors who answered the call to join the Arab Revolt. In 1918, many took part in the campaign of harassment that disrupted the supply lines and wrecked the railway connections used by Ottoman forces. A15562 Paul Castelnau

Baghdad, Iraq 10 April 1927
These children live in an orphanage run by the French order of nuns known as the Sœurs de la Présentation in Baghdad. It is possible that some of them were either infants whose parents had been killed during Ottoman massacres against Armenian, Assyrian and other Christian minorities in 1915, or the abandoned babies of women raped by troops during these atrocities. A53776 Frédéric Gadmer

Najaf, Iraq 19 April 1927
Gadmer met these two imams in Islam's holy city of Najaf, southwest of Baghdad. Home to the mosque of Imam Ali, who was a cousin of the Prophet Muhammad, Najaf receives more Muslim pilgrims than any city outside Mecca and Medina.
A53979 Frédéric Gadmer

Mosul, Iraq 10 May 1927
After the First World War, when the city was administered under the British mandate, Mosul was exceptionally diverse, with Sunni Arabs, Turks and Kurds living alongside Assyrian and Armenian Christians, including the women seen here. Mosul no longer enjoys such rich diversity: since the removal of Saddam Hussein in the Iraq War, lawlessness and violence have forced many Christians out. A54234 Frédéric Gadmer

Zakho, Iraq 11 May 1927
In their traditional brightly coloured, multi-layered dresses, these Kurdish women are fetching water near Zakho, in northern Iraq. In 1920, under the terms of the Treaty of Sèvres, the Allied Powers promised the Kurds an independent homeland, but the commitment was never honoured. They have been fighting for self-determination ever since. A54305 Frédéric Gadmer

Basra, Iraq 24 April 1927

Home of the Shatt-al-Arab waterway created by the confluence of the rivers Tigris and Euphrates, Basra is also veined with numerous inlets and canals. This view shows part of the Ashar district, where Basra's bazaar and corniche, or riverfront promenade, are situated. The city was once known as 'the Venice of the East', but since the US-led invasion of Iraq in 2003 – and despite the best efforts of the British troops who occupied it – Basra has been gripped by violence, chaos and insurgency. This once-vibrant port with diverse populations of Muslims, Christians and Jews is today peopled almost exclusively by Shia Muslims.

A54035 Frédéric Gadmer

Shiraz, Persia 18 September 1927
At this time, these clerics, led by the Grand Mullah of Shiraz, Sheikh Morteza, wielded little power outside their mosques: in Persia (now known as Iran) politics remained essentially secular. The mullahs would have to wait over half a century before they would gain power in a newly theocratic Iranian state. A53458 Frédéric Gadmer

Hamadan, Persia 4 October 1927
These Jewish schoolgirls attend an institution run by the Alliance Israélite Universelle, an organisation established in 1860 by French philanthropists and intellectuals to defend Jewish rights and support Jews who were suffering persecution in Eastern Europe. In 1898 it founded this school in Hamadan, one of a network of academies throughout the Middle East. A53543 Frédéric Gadmer

8 Africa

Among the very first entries in the Musée Albert-Kahn's registers is a plate numbered A6. Shot by the photographer Jules Gervais-Courtellemont (1863–1931) during his 1909 visit to Algeria, it is a simple image of a humdrum event: it shows nothing more thrilling than a young woman weaving a carpet. Although she is pictured from behind, we can see her fingers drawing threads between the cords stretched vertically over the loom. It is reasonable to assume that she is making it for the tourist market, because the word 'souvenir' is woven into its design.

Superficially, at least, the scene is unremarkable: a straightforward depiction of a quotidian event in an unexceptional North African setting. Yet the interplay of colour is an opera of visual delights. The rich crimson of the girl's headscarf is a shrill counterpoint to the yellow vibrato in her carpet, the gold coloratura of her blouse and the blue baritones of the rug below.

By adopting the autochrome process, pioneers like Courtellemont could produce images of unprecedented chromatic richness, intensity and subtlety at a time when very few people had seen any colour photographs at all. Inevitably, when his pictures were revealed to the public, they were received with unalloyed rapture. To many, the invention of the autochrome proved that at the beginning of the twentieth century, photography was standing on the threshold of a new era: the dawn of *L'âge de la couleur*.

When Courtellement's pictures came to the attention of Albert Kahn, he was so captivated by their beauty that he resolved to acquire them. By then, Kahn had already had some inkling of the aesthetic potential of the autochrome, since his chauffeur Alfred Dutertre had used the process in the United States, Canada, Japan and China during their round-the-world expedition of 1908–9. But the professionalism and flair of Courtellemont had produced images that were more ravishing and nuanced than anything Dutertre could muster. In experienced and talented hands, the prodigious possibilities of this infant process had become immediately apparent.

Although Kahn had acquired Courtellemont's works, the photographer's expedition to North Africa had not been conducted at Kahn's behest. But in the years ahead, Kahn and the Director of the Archives of the Planet, Jean Brunhes, would dispatch their own teams of photographers on eight future missions to the lands of northwest Africa, known collectively as the Maghreb.

◀ Photographed in colour in 1909, the young weaver at this loom in Algiers was probably working from home. For many families, rug-making was a cottage industry.
A6 (detail) Jules Gervais-Courtellemont

▲ The pioneering French *autochromiste* Jules Gervais-Courtellemont directs members of Algeria's Ouled Nail in 1909. (A colour image from this session is on page 290.)

Among the most intriguing of these assignments was undertaken by one of Kahn's most determined, assiduous and entertainingly irascible photographers. Stéphane Passet first arrived in Morocco in January 1913, just six months after making the first of his two visits to Mongolia. Almost three hundred of the autochromes shot by Passet during his Moroccan sojourn have survived in the Kahn Archives. Mostly shot in or near the northern city of Fez, Passet's pictures include several studies of the Tirailleurs Sénégalais who had been either recruited or conscripted by the French from their colonies in Africa.

At the Kahn Archives, papers relating to some of Passet's images suggest that at least one of the people who appeared in his photographs was a slave. It is true that the institution of slavery was still extant in some of the French colonies of the Maghreb in 1913. Indeed, in the case of Mauritania it was flourishing. Although the French had taken control of Mauritania in 1910, they had decided not to abolish slavery on the grounds that it would be too disruptive and damaging to indigenous traditions and social structures. There, as elsewhere in the colonies, the time-honoured Gallic principles of *Liberté, Égalité et Fraternité* were readily sacrificed on the altar of pragmatism.

Apart from expeditions to Egypt undertaken by Auguste Léon and Paul Castelnau (in 1914 and 1918 respectively), Kahn's photographers concentrated their African efforts on documenting life in the French colonies of the north. In a series of exquisite autochromes, they framed the traditional adobe-based vernacular architecture of North Africa against the vast sands of the Saharan landscape.

Purely in terms of the historical importance of the events they witnessed, probably the Archives of the Planet's most important mission to the Maghreb began on 18 June 1926, when two of Kahn's

photographers, Georges Chevalier (1882–1967) and Camille Sauvageot (1889–1961), arrived in Morocco. Their presence in this volatile corner of North Africa came just three weeks after the collapse of the Republic of the Rif – the self-proclaimed independent government of the indigenous Berber peoples who had been fighting French and Spanish colonial rule. It had taken a massive combined army of around a quarter of a million French and a hundred thousand Spanish troops to defeat the Rif forces, which were only about sixty thousand strong.

In the years before the Berbers established their republic, their resistance to colonial rule had hardened because of the implementation of an economic regime that was disproportionately detrimental to the colonised people. In parts of the country, land was summarily sequestered and given to new French settlers. A heavy tax burden was levied on ordinary Moroccans, which left many people destitute, while European expatriates were entirely exempt. It is perhaps indicative of the cynicism of French colonial rule in this period that despite the iniquitous nature of these policies, one of their authors, the French Resident-General Hubert Lyautey (whose portrait appears on page 317), was eventually forced to resign from office in 1925 partly because some in Paris considered him insufficiently robust in handling protests by the increasingly fractious 'natives'.

With discontent burgeoning among her imperial subjects, France urgently needed to maintain a strong and conspicuous military presence in North Africa. Legions of French soldiers had been sent to Morocco to shore up its colonial authority. To provide recreation for the new arrivals, Lyautey authorised the establishment of a so-called 'special quarter' in Casablanca, which was dedicated to satisfying the libidinal urges of the French servicemen. Scores of prostitutes were cloistered in what might be called this *arrondissement érotique*. On French insistence, the women needed special permits to

▼ A proud Tirailleur Sénégalais stands to attention in Fez in January 1913, a year after the military action that gave France control of Morocco. A831 Stéphane Passet

prove they were in good health before they were allowed to leave the district because of fears that they might spread venereal disease. Naturally, their French clients faced no such constraints.

As Camille Sauvageot's extraordinary film footage demonstrates, the women seem happy and playful in the presence of the camera. Indeed, intermittently they perform with cavalier abandon, hoisting up their dresses to bare their breasts. Whether this brazen exhibitionism was commonplace in the sexually uninhibited atmosphere of the quarter or was a compliant response to the sordid urgings of Sauvageot is, at this remove, impossible to tell. Certainly, there is no obvious evidence of either coercion or inducement in these images: if anything, their display seems spontaneous, confident and even exuberant. Nevertheless, Sauvageot's films of the prostitutes of Casablanca are at best an ambivalent spectacle.

Complementing his collection of around 4300 autochromes of the region, Albert Kahn's film archives are a rich pictorial record of both the everyday and exceptional aspects of North African life. But the representation of the people and cultures of sub-Saharan Africa is considerably less comprehensive and wide-ranging. Apart from a few acquisitions (most notably film footage of the 1916 coronation of the Empress Zawditu of Ethiopia, the first woman to become a head of state in modern African history – and a very curious dramatised film on sexual practices in Madagascar), before 1930, the Archives of the Planet possessed a relatively paltry collection consisting of thirteen autochromes that were shot south of the Sahara. These were snatched, somewhat messy images shot in Djibouti (then known as French Somaliland) by the normally meticulous

▶ On 22 July 1914 a young trader hawks his catch on the streets of Djibouti – a country where today over half of the population is under twenty years old. A5071 (detail) Léon Busy

▼ People in the town of Abomey, Dahomey (now Benin), prostrate themselves in readiness for the appearance of their King on 28 February 1930. A63589 Frédéric Gadmer

Léon Busy in 1914; presumably they were grabbed hastily during a short stopover en route to his principal assignment in Indochina.

But at the end of 1929, an opportunity arose that would enable Kahn to address this deficiency. One of his most experienced *opérateurs*, Frédéric Gadmer, was invited to accompany the Catholic missionary Père Francis Aupiais to the French West African colony of Dahomey, now known as Benin. After thirty years working with the Church's Society of African Missions, Aupiais was venerated in Dahomey. Yet in his French homeland he remained a controversial figure because he espoused some distinctly unconventional views about the responsibilities inherent in the Christian missionary role. Aupiais still embraced the idea of converting Africans to Christianity, but he believed that it was possible to do so without sweeping away traditional religious beliefs, rituals and practices in the process. In the case of Dahomey, Aupiais was advocating the possibility of a kind of spiritual cohabitation at the local level between Catholicism and the country's indigenous religion – Vodun.

Not surprisingly, to many within the Church the idea that there could be any moral equivalence between the One True Faith made manifest in biblical scripture and the paganism of Vodun was considered at best absurd and at worst downright heretical. According to his diaries, on several occasions during their journey to Dahomey, Aupiais discussed religious ideas with Gadmer. Initially Gadmer seemed cold, withdrawn and taciturn; nonetheless, as Aupiais's diaries reveal, the cleric was drawn to him as their journey progressed: 'I always find him alone whenever I go up on the bridge. But he is neither a misanthrope nor sad. He is a man of singular character, but of very rich personality. I am starting to think that we will be friends.' A few days later,

▼ Chief Zodéougan is encircled by his entourage in the town of Zado, near Dahomey's former capital, Abomey, on 28 February 1930. A63555 Frédéric Gadmer

Aupiais added: 'Mr Gadmer interests me more and more. He reads discerningly, talks intelligently, judges with wisdom and feels delicate emotions with finesse. But his demeanour is cold, almost rude. One does not see him talking to anyone.'

Between January and May 1930, Gadmer shot almost seven hours of monochrome film, and nearly eleven hundred autochromes. The film historian Sam Rohde has described the footage, which contains what is probably the earliest extant recording of real Vodun ceremonies in the world, as 'one of the most important documents of the modern cinema and evidence of the cinema's modernity'. Gadmer's autochromes present a different, though equally important, visual testament. The subjects appearing in his pictures span all strata of Dahomean colonial society. Throughout the collection, kings, chiefs and priests jostle with nuns, weavers and musicians. Likewise, Gadmer's autochromes cover all dimensions of the country's cultural life: specific details of its architecture and religious practices, as well as the subtle orientations of its modes of dress.

Without the images that Gadmer shot in Dahomey in 1930, Albert Kahn's holdings of autochromes from sub-Saharan Africa would be negligible. Yet the uniqueness of the Dahomey images is just a single chord in the concerto of virtues that emerge from Gadmer's work. Produced at a moment when – reductively and shamefully – Western culture equated everything African with the primitive, brutish and savage, his images present us with a society that

▲ Père Francis Aupiais outraged Catholic leaders by insisting that Dahomey's indigenous religions were comparable to other faiths – including Christianity. A51431 Auguste Léon

is rich, complex and civilised. Many of his pictures evince respect and affection for those caught in his gaze. These autochromes contest the delusional narratives that dominated Western thinking about African culture in the first half of the twentieth century. Frédéric Gadmer's films and photographs bequeath an unswervingly candid yet consistently sympathetic picture of African life at a time when corrosively racist mythologies that denied the humanity of Africans were colonising the mental environment of the West.

Taourirt Amokrane, Algeria 1909–11
All appears tranquil in Courtellemont's landscape of Taourirt Amokrane, yet across Algeria there was burgeoning discontent with French colonial policies, especially the settlers' brutal land confiscations, inequitable tax laws, and conscription. Emerging nationalist groups were campaigning for democracy and property rights, but it would take fifty years, and a bloody war of independence, before France relinquished power. A17 Jules Gervais-Courtellemont

Biskra, Algeria 1909–11

A family from the town of Biskra in northern Algeria prepares one of the great staple dishes of North Africa. Couscous is made from semolina granules that are moistened with water, rolled by hand and repeatedly sieved. Now enjoyed around the world, the dish originated here among the Berbers (or, more correctly, Imazighen) of North Africa.

A51 Jules Gervais-Courtellemont

Bou Saada, Algeria 1909–11
Within Algeria, the town of Bou Saada became famous for its association with the Ouled Nail – a people whose womenfolk were trained in childhood to dance provocatively (sometimes naked) for men. It was accepted practice for these young dancers to work in this indigenous sex industry until they reached their mid-twenties, when they would often use the money they had earned as marriage dowries. A81 Jules Gervais-Courtellemont

Bou Saada, Algeria 1909–11
Ouled Nail dancers wore kohl eye make-up, facial tattoos, plaits, and silk robes accessorised by a profusion of trinkets – extravagant earrings, bracelets and tiaras. Their jewellery was further ornamented with gold or silver coins gleaned from customers. Today a stricter interpretation of Islamic moral codes in Algeria has forced the Ouled Nail to abandon many aspects of their way of life. A80 Jules Gervais-Courtellemont

Ben Guerir, Morocco December 1913
These people live in a *douar* – an arrangement of tents creating a livestock enclosure – almost certainly in the town of Ben Guerir, near Marrakesh. This place would be transformed in subsequent years: during the 1950s the US Strategic Air Command established a hi-tech base here that was eventually equipped to support the Space Shuttle launches of the 1980s and 90s. A912 Stéphane Passet

Sido Bou Othmane, Morocco January 1913
Like their sisters in the Algerian Ouled Nail, these Moroccan women, from a *douar* at Sido Bou Othmane near Marrakesh, wear brightly coloured robes and go without the veil. But the resemblance ends there. Their kaftans are simple, yet supremely functional – designed to protect their skin from harsh sunshine and the sandstorms that lash the Sahara.
A904 Stéphane Passet

Safi, Morocco 21 June 1926
Youngsters crowd in front of Chevalier's camera in the fishing port of Safi on Morocco's Atlantic coast. Safi was once controlled by Portugal, although Morocco fiercely resisted colonisation for most of its history. The country was the only North African nation to avoid absorption into the Ottoman Empire, and for much of the nineteenth century it thwarted the imperial designs of the French as well.
A49698 Georges Chevalier

Marrakesh, Morocco 18 June 1926
Today Djemma el-Fna – which translates as 'The Square of the Dead' – pulsates with merchants, holy men, snake charmers, necromancers and street performers. When Chevalier visited it, there were few Western tourists to absorb the spectacle. Nonetheless, it was already a popular gathering-place, overlooked by the minaret of the twelfth-century Koutoubia Mosque, which happily survives to the present day.
A49648 Georges Chevalier

Marrakesh, Morocco December 1912
Many of the children in this *mellah* (ghetto) in Marrakesh were likely to be descendants of Jews who had fled to Morocco to escape the persecutions of the Spanish Inquisition. By the early twentieth century, the Jewish population of Morocco exceeded a quarter of a million; today fewer than 3000 remain, of whom about 250 live in Marrakesh.
A920 Stéphane Passet

Tunis, Tunisia 1909–11
These young women are also Jewish, though they hail from Tunisia's capital, Tunis. Like their co-religionists in Morocco, the Jewish population of Tunisia dwindled in the twentieth century: many thousands emigrated to France and especially Israel in the 1960s. Fewer than 1400 Jews live in Tunisia today. A35 Jules Gervais-Courtellemont

Tunis, Tunisia 1909–11
According to Courtellemont, the laid-back entrepreneur in this autochrome was running the oldest pottery shop in Tunis. This is not entirely inconceivable, but similar emporia would have existed in the city's numerous ancient *souks* – some of whose owners might well have contested this claim. A30 Jules Gervais-Courtellemont

Al Qayrawan, Tunisia 6 May 1931
The ancient suburb of Djedid lies in the city of Al Qayrawan around 50 miles west of Monastir. One of Islam's holy cities, Qayrawan was once declared the capital of the Maghreb, and established itself as one of the great administrative, intellectual and commercial cities of the Islamic world.
A65440 Frédéric Gadmer

◀ **Giza, Egypt** 6 January 1914
Léon's Egyptian autochromes include what may be the earliest colour photograph of one of the world's great man-made spectacles. Behind the Sphinx stands the Pyramid of Khufu (or in Greek, Cheops), which is not merely the largest of Giza's three pyramids, containing 2.3 million stone blocks each averaging 2.5 tons, but is possibly the most colossal single building ever built.
A3023 (detail) Auguste Léon

Luxor, Egypt 3 October 1918
Near Luxor, Castelnau discovered these *fellahin* (agriculturalists) exploiting a technology that has been used for at least four thousand years. The *shaduf* is made from a wooden upright upon which pivots a pole with a bucket at one end, and a counterweight at the other. The counterweight makes moving the receptacle almost effortless. *Shadufs* are still used for irrigation in rural Egypt today. A15967-AT Paul Castelnau

Luxor, Egypt 13 January 1914
Traditional Egyptian *feluccas* have sailed the Nile, and have moored here at Luxor, since the age of the Pharaohs. They are still used to ferry people, goods and livestock along the world's longest river, though nowadays many – especially those serving tourists – are fully motorised and no longer depend on the Nile's gentle breezes. A3154 Auguste Léon

Cairo, Egypt 6 February 1914
A drinks vendor seeks customers on the streets of Cairo in 1914. At the end of that year, the people of Egypt were living in a newly declared British Protectorate. By then, Britain would be at war with Egypt's old Ottoman overlords, and though it did not enforce conscription, martial law was declared – a move that strengthened the cause of Egyptian nationalism. A3532 Auguste Léon

Aswan, Egypt 20 January 1914
These are the children of the Bisharin nomads who graze herds across southern Egypt and Sudan. Part of the Beja people, they had at various times fought battles both alongside and against the British. In one of his poems, Rudyard Kipling derided the Beja as 'Fuzzy-Wuzzies' – though he also acknowledged their fighting abilities, and saluted them for 'breaking the British square'. A3276 Auguste Léon

Sakété, Dahomey 14 January 1930
In Sakété, a little north of the capital Porto Novo, this group of percussionists (known as a *bata*) are playing Yoruba drums. Usually carved from a single tree-trunk, these instruments were used to provide musical accompaniment to important ceremonies and rituals honouring the deities of the Vodun religion. A63190 Frédéric Gadmer

▶ **Oumgbègamè, Dahomey** 8 March 1930
This is the considerable figure of Paramount Chief Justin Aho, here attended by his wives in the town of Oumgbègamè near Abomey. Like his uncle, the deposed King Behanzin, Aho was a generous patron of Dahomey's indigenous artists, and used his wealth to support many sculptors, carvers and mask-makers. A63640 (detail) Frédéric Gadmer

Zado, Dahomey 28 February 1930
These members of Vodun's Zomadonou sect honour fetishes representing the Tohossou – the Gods of Water. Legends associated with this tradition have helped to end persecution and discrimination against physically disabled children. At one time, such children were looked on as a curse, but because they are deemed to enjoy the protection of the Tohossou, they are now considered to be a blessing to their families. A63583 Frédéric Gadmer

Dagbé, Dahomey 2 February 1930
West Africa's great mask-making traditions are evident in Benin, where head-dresses are worn in festivals and religious ceremonies. In the town of Dagbé, near the present-day capital Porto Novo, this man wears a mask representing an Onigangan (drummer). In some rituals, he is represented as an imperious figure who insistently plays music on the streets. A63356 Frédéric Gadmer

Dahomey 27 January 1930
When weaving was first introduced to Benin, it became the speciality of a small number of families, mostly based in a quarter of Abomey. This weaver is using the so-called Soudanien method, involving a large outdoor loom – a technique exclusively adopted by men. A63305 Frédéric Gadmer

Abomey, Dahomey 6 March 1930
These women are guarding the tomb of King Glélé in Abomey. During his reign (1853–89), Dahomey cemented its position as one of the most powerful states in West Africa. Women had long performed special security functions there: Dahomey's army included a large elite corps of women warriors, who fought in many military campaigns, including the colonial war against the French. A63625 Frédéric Gadmer

Koudenndongou, Dahomey 17 March 1930
In the village of Koudenndongou in the foothills of the Atakora Mountains of northern Dahomey, Somba men stand in front of the distinctive castle-shaped, multi-storey dwellings known as *Tata Somba*. Today the Somba wear clothes, but they have maintained their tradition of hunting with bow and arrow.
A63701 Frédéric Gadmer

9 Portraits

Albert Kahn's collection includes more than five thousand portraits of his friends, associates and acquaintances. The majority had little or no public profile in their own day, and remain unknown in ours. Others were renowned in their own time, but have since slipped into obscurity. But among Kahn's autochromes are portraits of some of the most significant personalities of modern times.

A few were shot with photojournalistic immediacy by Kahn's photographers while their subject was in action, sometimes during events of considerable historical importance. But the majority by far were shot by two of the Archive's *opérateurs*, Georges Chevalier and Auguste Léon, at Kahn's elegant estate in Boulogne-Billancourt. Occasionally, the financier's *opérateurs* invited their subjects to stand in the serene, picturesque surroundings of their employer's French, English and Japanese gardens. Typically, though, they opted to shoot them inside Kahn's mansion while seated in front of a relatively prosaic backdrop.

Some of those appearing in the portrait collection were involved in one or more of Kahn's ancillary social, cultural and political organisations. In 1916 he had established his Comité National d'Études Sociales et Politiques (CNESP) as a forum for academics, intellectuals, activists and politicians to debate the issues that concerned them. Four years later he founded his Centres de Documentation Sociale to publish periodicals and bulletins on politics, international relations, social affairs and suchlike. Numerous portraits in the Archives feature

▲ Banker and philanthropist Baron Edmond de Rothschild (1845–1934), who lived near Kahn in Boulogne-Billancourt. C865 (detail) Auguste Léon (Cap Martin, February 1925)

◀ The great French writer Sidonie-Gabrielle Colette (1873–1954), author of *Gigi* (1944), which inspired the musical starring Maurice Chevalier. A35731 Roger Dumas (22 November 1922)

▲ Alexander Kerensky (1881–1970) Russian Prime Minister (July–October 1917). A25419 Georges Chevalier (24 March 1921)

▲ British statesman Sir Austen Chamberlain (1863–1937), winner of the 1925 Nobel Peace Prize. A62723 (May 1930)

▲ J. J. Thomson (1856–1940), the British physicist who discovered the electron and won the Nobel Prize in 1906. A40292

▲ French Premier Léon Bourgeois (1851–1925), who won the Nobel Peace Prize in 1920. A62079 Georges Chevalier (1917)

▲ Moriyuki Motono (b. 1925), grandson of Kahn's friend, the Japanese statesman Ichiro Motono. A60347 Georges Chevalier (1929)

▲ King Alexander I of Yugoslavia, who ruled from 1921 until his assassination in 1934. A19197 Auguste Léon (1919)

individuals who had contributed to these and other satellite operations run by Kahn.

One of the largest constituencies within the portrait collection is that of the *boursiers*. Organised under the name of the Société Autour du Monde, past recipients of Kahn's travel scholarships would gather at the Boulogne-Billancourt estate for Sunday lunch. By all accounts these were convivial affairs, where the *boursiers* reminisced about their travels, exchanged ideas about the state of the world and watched screenings and projections of Kahn's films and autochromes. Occasionally, special guests were invited to these gatherings. Some, though it appears not all, allowed Kahn's *opérateurs* to shoot their portrait on autochrome.

Drawn from virtually every sphere of public life, those whose portraits appear in the Kahn Archives include the great French sculptor Auguste Rodin, the industrialist André Michelin, the British scientist J. J. Thompson, and the inventor of the autochrome system himself, Louis Lumière. There is a generous smattering of royalty too: King Alexander I of Yugoslavia is here, as are Prince Yasuhito and Princess Nobuko Asaka, and Prince Naruhisa and Princess Fusako Kitashirakawa, of Japan. They are joined by, among others, Prince and Princess Chivekiar of Egypt, Prince Yi Un and Princess Yi Pang-ja of Korea, and sundry counts, marquises, barons and maharajahs from across the globe.

Statesmen are found in abundance. As well as a Greek Prime Minister, Eleuthérios Venizélos, and a British counterpart, James Ramsay MacDonald, there are no fewer than four French ones: Léon Bourgeois, Raymond Poincaré, Aristide Briand and Albert Sarraut. Briand was a winner of the Nobel Peace Prize, as were two British politicians who appear in the Archives, the former Foreign Secretary Austen Chamberlain, and one of the founders of the League of Nations, Lord Robert Cecil. Nobel Literary Laureates are strongly represented as well: Thomas Mann, Anatole France and Rabindranath Tagore, as well as one of Kahn's dearest friends, the great philosopher Henri Bergson, who won his Nobel Prize in 1927.

Several other exalted figures are known to have visited Kahn, yet portraits of them were either never produced or are now lost. Sadly, the literary giants James Joyce, Rudyard Kipling and H. G. Wells are in this category, as are the French prime minister Georges Clemenceau, the economist John Maynard Keynes and two of the greatest scientists of all time, Albert Einstein and Marie Curie.

Considered in its entirety, this collection of portraits is notable for reasons other than the illustrious character of its membership. It is striking how exceptionally global Kahn's circle of acquaintance was, particularly for its time: clearly, this is a man whose commitment to internationalism was more than merely rhetorical. Furthermore, though there is a discernible bias towards those of liberal-progressive persuasions, many individuals featured held political positions that were very distant from those of their Jewish, pacifist host. As well as

▲ Left to right: Journalist Simone Téry (1897–1967), who reported on the Spanish Civil War; Nobel Prize-winning German author Thomas Mann (1875–1955); and the French Nobel literary laureate Anatole France (1844–1924).
A65128, (May 1931); A 65091 (May 1931); A15468 (May 1919)

▶ Born in Paris in 1840, the great sculptor Auguste Rodin created many celebrated works, including *The Thinker* (1880) and *The Kiss* (1886). Rodin died in Meudon, near Albert Kahn's home in Boulogne-Billancourt, in November 1917.
Photographer unknown (October 1908)

numerous portraits of men drawn from the higher ranks of the French military, there are images such as those of the right-wing, anti-Semitic, anti-Dreyfusard novelist and politician Maurice Barrès, and the devoutly Catholic, conservative poet Paul Claudel, who would later be an apologist for the Nazi-collaborating Vichy government of Marshal Philippe Pétain (whose portrait is also present in the Kahn Archives).

Just as many of Kahn's autochromes were intended to preserve photographically those aspects of the world that were doomed to disappear, so his formal portraits seem to have been commissioned very deliberately with posterity in mind. An instinctive optimist like Kahn might have suspected that a century hence, ancient monuments such as Angkor Wat, the Taj Mahal and the Pyramids would still survive in some form; but he must have been doubtful that the fame of the French author Colette or the British statesman Austen Chamberlain would. With characteristic prescience, Albert Kahn realised that in many cases his portraits would be the only colour pictures ever taken of some of the most important people of his age.

PORTRAITS

315

Cap Martin, France February 1923
The eleventh child and seventh daughter of the Meiji Emperor Mutsuhito (1852–1912), and sister of the Taishō Emperor Yoshihito, Princess Fusako Kitashirakawa (*née* Kane, 1890–1974) married the Japanese aristocrat Naruhisa Kitashirakawa in 1909. Tragically, he died in a car accident in Paris in April 1923.

A38657 Roger Dumas

Boulogne-Billancourt, France 11 May 1927
Marshal Louis-Hubert Lyautey (1854–1934) was one of the leading French soldier-statesmen of his age. He fought in numerous colonial campaigns, including those in Algeria, Madagascar, Indochina and Morocco, where he became the protectorate's first Resident-General in 1912. In France Lyautey served briefly as Minister for War (1916–17), but later returned to Morocco, which he governed until his retirement in 1925. A51046 Georges Chevalier

Boulogne-Billancourt, France 29 May 1929
Born at Cauchy-à-la-Tour in 1856, Marshal Henri-Philippe Pétain became a national hero after commanding the French defence at Verdun in 1916. But after the Second World War, Pétain – who had led France's Nazi-collaborating Vichy regime – was tried as a traitor and given the death penalty. His sentence was commuted to life imprisonment in solitary confinement, and he died in a French jail in 1951. A59777 Georges Chevalier

Le Mans, France August 1908
On 17 December 1903, at Kitty Hawk, North Carolina, the pioneering American aviators Wilbur Wright (1867–1912) and his brother Orville (1871–1948) became the first men to make a controlled, sustained self-propelled flight in a heavier-than-air machine. At first, their achievement had been widely disbelieved in Europe. But all doubt was dispelled in the summer of 1908, when (for the benefit of French investors) Wilbur sailed to Europe, and staged demonstrations of his flying machine at the Hunaudières racecourse near Le Mans. These stereoscopes – the only known true-colour pictures of Wilbur's display – were taken less than four years before he contracted typhoid fever, and died at his home in Dayton, Ohio, aged forty-five. Probably Alfred Dutertre

Boulogne-Billancourt, France June 1921

Strolling serenely through Albert Kahn's rose garden is the Calcutta-born poet, songwriter, playwright and painter Rabindranath Tagore (1861–1941). A towering figure in modern Bengali literature, Tagore's acclaimed poetry collection *Gitanjali* (*Song Offerings*) of 1912 did much to raise awareness of Indian writing in literary circles around the globe. A close friend of Kahn and a frequent visitor to the banker's homes in France, Tagore achieved international recognition in 1913, when he became the first Asian writer to be awarded the Nobel Prize for Literature. Two years later Tagore was also awarded a knighthood, but he relinquished it after British troops shot and killed hundreds of unarmed civilians during the Amritsar Massacre of 1919. A36199 Georges Chevalier

APPENDIX 1
The Autochrome Process

In 1861, the brilliant Scottish physicist James Clerk Maxwell created what most historians of photography consider to be the first true-colour photograph. Maxwell achieved this by shooting three separate images of a tartan ribbon. Before taking each shot, he placed a different coloured filter in front of the lens. Thereafter, the plates were developed and mounted in three different projectors, each of which was positioned in front of the corresponding colour filter. By focusing and superimposing the images on each other, Maxwell had produced a full-colour photograph.

But Maxwell's process was difficult and expensive: photographers needed a less cumbersome way of reproducing the true colours of nature. A technological solution to the problem would prove to be surprisingly elusive, until a pair of French brothers developed a process that was portable, needed a single glass plate, could be used with existing cameras – and produced outstanding images.

At their laboratories in Lyon, Auguste and Louis Lumière made their decisive breakthrough by finding an unconventional use for an utterly prosaic ingredient: the potato. They spread approximately 4 million grains of potato starch over each square inch of a glass plate, and carefully flattened them with a roller. The grains – which had been dyed red, green or violet – acted as minuscule coloured filters. When the plate was exposed, light entering the lens

◀ The painterly, almost impressionistic quality of the autochrome, which has been compared to the *pointillisme* of the French artist Georges-Pierre Seurat, is evident in this view of the city of Zahlé in Lebanon, taken on 27 November 1919. A19869 (detail) Frédéric Gadmer

▶ Through a microscope, the individual red, green and violet grains of potato starch on an autochrome plate are revealed.

passed through the grains on to a layer of photographic emulsion. Once processed, the plate yielded a positive full-colour image.

The Lumières were already famous after the public demonstration of their *cinématographe* in Paris in December 1895. But they were convinced that their colour photographic system was a development of immeasurably greater historical significance.

When magnified, the image created on the surface of a typical autochrome plate appears fragmented, even pixillated: the potato grains resemble undissolved particles suspended in a fluid, their Brownian motion frozen in the frame. Yet viewed at a distance, the process yields spectacular results. Its blues have

APPENDIX 1

322

◀ The double lens configuration of this projector, manufactured by the Radiguet & Massiot Corporation, enabled cross-dissolves between autochrome slides.

▶ Lumière autochrome plates were usually sold in boxes of four and cost four times as much as their monochrome counterparts.

▼ A wooden, tripod-mounted bellows camera, typical of the kind used to expose 9 × 12 cm glass autochrome plates.

a soft intensity, like a crystal seen through gauze. Its greens vibrate and crackle with a verdant energy. Its reds are fierce and arresting. Perhaps this is best seen in the gorgeous crimson garments traditionally worn by the women of the Claddagh, in the west of Ireland. In the series of pictures shot by Marguerite Mespoulet in 1913, their shawls are like vivid carmine smears against the pallid tones of the cottages, streets and skies.

However, the process does have its detractors. As well as the frustrations created by the relatively long exposure times it requires – the reason that in so many images motion is reproduced as a smudge – some critics have pointed to certain technical deficiencies in the system's reproduction of the colour yellow. Yet throughout the Kahn collection there is an abundance of autochromes – including, notably, Léon Busy's brilliant portraits of a theatre troupe in Vietnam – that demonstrate its capacity to cope with even the most psychedelically hectic scenes.

In many autochromes, human figures have a softness that makes them ethereal, even ghost-like. Landscapes, too, have a painterly imprecision, as though the process strives to deny its mechanical origins. If the autochrome process has technical limitations, it seems to overcome them triumphantly. As the historian John Wood has insisted, the Lumières' invention generates images that are 'the rarest, most fragile and, to a great many eyes, the most beautiful' in photographic history.

◀ A world of colour: the crimson shawl of a Claddagh colleen (1913); the vibrant green of the Irish countryside (1913); the rich blue robes of the Governor of Ha Dong province in Vietnam (1914 or 1915); and the bright yellow blooms of an Indian flower-seller in Amritsar (1914). A3641 and A3709 Marguerite Mespoulet; A5174 (detail) Léon Busy; A4214 (detail) Stéphane Passet

APPENDIX 2
Albert Kahn: The Man and His Legacy

Gilles Baud-Berthier, Director of the Musée Albert-Kahn

What would you do if you were rich – really rich? Would you indulge in life's pleasures to the full? Would you become a patron of the arts? Or would you turn away from a life of fun, fame and perhaps futility? Would you devote your life and your entire fortune to the good of others? If your answer to the last question is yes, you could be a philanthropist in the mould of Albert Kahn.

This seems a good place to offer a few keys to understanding this extraordinary man. Very little is known about him, even though the guests invited to his home included many of the major international figures of the time. All were drawn by the reputation and work of a Frenchman who was at once very rich, very private and entirely devoted to the good of humanity. To lift the veil on this paradoxical man, we shall start with war.

In 1870 France lost a war against Prussia, and French populations in the border provinces of Alsace and Lorraine had to make a terrible choice: they could either stay in their homes and become citizens of the new Germany, or abandon them and emigrate in order to remain French. The Kahn family opted for France. It was then that ten-year-old Abraham changed his name to Albert. This was a symbolic act that clearly underlined his choice to be French, but its significance went beyond that.

◀▲ The original wooden boxes that have held Albert Kahn's legacy of early colour photographs for a century are still kept at his former home in Boulogne-Billancourt. Pascal Bédek (both)

The name change set the seal on the bond between the young Jewish émigré from Alsace and his country of France, and indirectly forged his attitude to his public life. Educated in the primary school system of the recently defeated Second Empire, Kahn had inherited its faith in progress, a belief that lay in the ideas of the eighteenth-century Enlightenment. The virtues of engineering and science had long been recognised: the rail network, for example, had been extended to every corner of France, enabling factories to spring up across the country. Then the empire collapsed, to be followed by the Third Republic. The ideals of the Revolution of 1789

▲ Albert Kahn's mansion in Boulogne-Billancourt today. There are plans to turn this building into a museum dedicated to telling the story of his life. Bénédicte de Changy

came back into fashion, and young French minds were set alight by the idea of a republican, secular France. The new Republic, like that of 1789, claimed to be indivisible; but in fact it had already been divided by the defeat of 1870. Although France recovered, expanding its empire in Africa and Asia, the French did not forget the small northeastern piece of their country that had been lost, biding their time until revenge could be theirs. The republican regime suited France's Jewish community: they had not forgotten that they owed their emancipation of 1791 to the First Republic. This intellectual ferment around his national and ethnic roots was the likely foundation stone of Kahn's political personality. He remained incontrovertibly secular, fiercely patriotic and sincerely convinced that humanity, when guided by reason, was fundamentally good.

Having attained both maturity and wealth, in 1910 Albert Kahn launched his great project to build a world memory through images. He called it the Archives of the Planet, in a clear reference to the spirit of the eighteenth-century encyclopedia. Kahn wanted the project to be systematic and to offer a means of preserving ways of life that were being transformed by the modern world. Perhaps he was recalling the contrast between the peaceful environment of his Alsatian childhood and the hectic French capital to which he had then moved. At that time, the 1870s, the old Paris was being swept away in the face of Baron Haussmann's urban planning, while beyond it the entire country was changing out of all recognition as industrialisation took hold.

Of all Kahn's qualities, the one most deeply rooted within him was his faith in reason, which is why he set up his bursary scheme. He was particularly keen that future teachers should benefit: if their own minds were opened to the realities of the world, he

argued, they would be better able to help their young charges see the virtues of tolerance. It comes as some surprise to learn that beneficiaries were given the simple mission of observing reality across the globe – after all, travel was very expensive at that time. Singularly privileged, these young people were being funded to travel in comfort for eighteen months on an itinerary of their own choosing. They were required to devise an associated study project, but otherwise the constraints were minimal. Further evidence of Kahn's progressive and broad-minded attitude was demonstrated by including women among the beneficiaries; likewise past wars were forgotten, and only current hostilities rendered any country's young people unable to participate.

The First World War offers a further key to Kahn the man. The first conflict to exploit the might of science and industry to the full, it had a determining influence on intellectual development in the West. It marked the end of the Enlightenment and the arrival of modernity. Before 1914 Europeans, and particularly the French, had believed in reason as a necessary element in progress. Humanity could only move towards a better world, they asserted, in a society enlightened by science. But this war demonstrated

▲ The Japanese garden is the most famous of several internationally themed gardens at the Albert Kahn estate near Paris. Pascal Bédek

that science could be used badly and to terrible effect. Reason would never rule the world and humanity was resistant to progress, since it had perverted science to produce industrial killing machines on a nightmare scale. The fundamental optimism that had reigned in the West since the eighteenth century was followed by a no less profound pessimism and a questioning of the very foundations of Western civilisation.

Yet Kahn continued to endorse his work for peace through reason. He still believed that if people could only get to know others from different cultures, ultimately their minds would open and universal peace

would be established. He was one of the few men to retain this belief after 1914. In this respect he was a typical man of the nineteenth century, perhaps even the eighteenth – but not the twentieth.

One part of Kahn's life may seem surprising: his secularism. He was, after all, of Jewish origin, and the Jewish community in France had tightened its ranks in 1894. It had been badly shaken by the guilty verdict passed on the Jewish army captain Alfred Dreyfus, falsely accused of spying for Germany, and still further troubled by the subsequent violent debates between his supporters and his detractors over their irreconcilable ideas about French society. Anti-Semitic arguments were widely aired in public. However, despite being a public figure, Kahn kept his distance from these events, and indeed visitors to his house included figures from both sides of the fence. Kahn did not, of course, deny his origins, as proved by the links he maintained over the decades with his remaining family and friends in Alsace. In later life he also began thinking about metaphysical questions, and sometimes sought answers in the religion of his forebears. It was simply that this was not his fight. His vision was so vast, the effort of persuasion he had to make so endless, that he did not get involved in what he might have seen as local arguments and crises. Albert Kahn was fighting for his own cause.

The paradox is heightened by the virulent attack on him by the extreme right-wing political activist

◀ Albert Kahn's gardens at Boulogne-Billancourt are visited by more than 80,000 people each year. Ronan Guinée

Léon Daudet, who lambasted 'the Jewish banker "Abraham" Kahn' in an article of 1920. Anti-Semitic fulminations of the day railed against international Jewry as hostile to the identity and prosperity of France. But Kahn's patriotism was never in doubt, even among right-wing polemicists. Indeed, at the start of the First World War he had set up an organisation to provide aid to refugees and civilian victims. Kahn's secularism was so unshakeable, his philanthropy so sincere, that his personal influence can be seen right across French society. He had access to all circles of power, all parties but the most extreme (the Bolshevik left and anti-republican right), and all Churches. Kahn's influence extended far beyond the French borders – his network was literally global.

After the Armistice, he gave his support to the League of Nations, precursor to the United Nations, whose aim was to promote peace throughout the world. The philosopher Henri Bergson, a friend of Kahn's who played an active role in the League, took the opportunity to pay tribute to one of Kahn's organisations, the Around the World Society, as inspiring the spirit of the United Nations. But Kahn himself never became fully involved in the League of Nations; for him, nothing really mattered but his own work.

Here we see the full paradox of his personality and world view. A typical Frenchman of the nineteenth century, embodying the ideals of the Enlightenment and the Revolution, Albert Kahn was nevertheless a citizen of the world, advocating universal tolerance

▲ The gallery at the Musée Albert-Kahn displays a selection of autochromes from the archive and holds regular exhibitions. Bénédicte de Changy and Pascal Bédek

for all peoples. A Jew so secular that all but the most hysterical of his natural enemies forgot his original faith, a public figure so utterly assimilated into the social fabric of the times that he had friends and acquaintances across the entire spectrum of international society, he still remained a solitary man on a self-imposed mission of pacifism.

The Wall Street Crash of 1929 proved disastrous to Kahn the banker. No crisis of such magnitude had ever been seen before, yet he chose to interpret it according to the criteria of nineteenth- and early twentieth-century financial collapses. Many other financiers made the same mistake. Kahn's attempts to get out of his difficulties, and his desperate efforts to continue funding his work, ultimately caused his bank to collapse.

Following his bankruptcy, the local authority bought his Boulogne-Billancourt property, where he was allowed to stay and where he died in November 1940, a few months after German troops had entered Paris. One might have expected Albert Kahn to die unhappy, since he was a convinced pacifist who had experienced three wars: the tragic war of 1870 during his childhood, the war of 1914–18 that reached the peak of atrocity when he was a mature man, and a war that was already horrific by the time of his death. Yet accounts of the end of his life suggest that he never lost faith in his ideas. Although he was financially ruined and living in an enemy-occupied country, Kahn's optimism about the future of humanity remained intact until his last breath.

The gardens at Boulogne-Billancourt had been opened to the public in 1937, and a small team was employed to put the photographic collection on display. During and after the war, Kahn's house and grounds were administered by the Seine local authority.

The administrative bodies in the Paris area were reorganised in 1964. Four years later, the newly

created *département* of Hauts-de-Seine took over any properties within its boundaries that had belonged to the old Seine authority. The new *département* went further and set up a museum in memory of Albert Kahn. Visitors now come every year in their tens of thousands to see the priceless images in his Archives of the Planet and to wander through his magnificent gardens. Today the Albert Kahn museum includes the banker's house, his 10 acres of historic gardens, 7000 square feet of exhibition space, numerous outbuildings and the film and autochrome collections. A team of some sixty experts employed by the local authority of Hauts-de-Seine, heir to a part of the world's memory, ensures that Albert Kahn's legacy lives on.

In one final paradox Kahn's period images, acquired by the most modern means available in their day, are now being preserved and displayed with the aid of cutting-edge technology, including digital photographic techniques, television, DVDs, the internet and high-quality four-colour printing combined with digital technology. The proof is this book, *The Wonderful World of Albert Kahn*.

The work of Albert Kahn, essentially a nineteenth-century man, has benefited from twenty-first-century forms of communication. But more traditional formats, such as this book, have not been neglected, and are available around the world. This heritage now belongs to everyone, in accordance with Albert Kahn's wishes and the universal scope of his work for peace. May this proof of the happiness conveyed by the spirit of tolerance long be carried far and wide to all who may be drawn to these Archives of our planet.

▲ The Musée Albert-Kahn, which was opened in 1990, ensures Kahn's legacy is preserved and made available for future generations to enjoy. Pascal Bédek

The Musée Albert-Kahn is based at Kahn's former home at 14 rue du Port in Boulogne-Billancourt, a suburb west of Paris served by Métro line 10. The museum and gardens are open daily between 11 a.m. and 7 p.m. from the beginning of May to the end of September, and between 11 a.m. and 6 p.m. for the rest of the year. For contact details and information in English about exhibitions and transport links, visit the Hauts-de-Seine website (www.tourisme-hautsdeseine.com).

Index of Countries

Pages on which photographs taken in the following countries appear

Algeria 280, 282, 288–91
Belgium 152, 154, 172
Benin *see* Dahomey
Bosnia 110–11
Brazil 86, 96–7
Bulgaria 119
Cambodia 258–9
Canada 80, 87, 90–5,
Ceylon (Sri Lanka) 227
China 4, 188, 189, 200–8
Croatia 113
Dahomey (Benin) 5, 284, 286, 304–9
Djibouti *see* French Somaliland
Egypt 300–3, 332
England 16–18, 21, 52–7, 139, 178–81
France 4–6, 8–10, 12–15, 19–20, 28–41, 130–8, 140–51, 153, 155–71, 173–7, 263, 287, 311–12, 314–19, 324–8, 330–1
French Somaliland (Djibouti) 285
Germany 4, 27, 76–9, 182–3
Greece 98, 101, 114–18
Holland 66–7
India 5, 192–3, 195, 216–26, 322
Iran *see* Persia
Iraq 274–7
Ireland 22, 42–51, 322
Israel *see* Palestine
Italy 24–5, 68–71
Japan 184, 186–7, 189, 196–9
Jordan 262, 272–3
Lebanon 264, 268–9, 320
Macedonia 100, 108–9
Mongolia 4, 189–91, 209–15
Montenegro 112
Morocco 283, 292–6
Norway 23, 58–60
Palestine (Israel) 270–1
Persia (Iran) 261, 278–9
Serbia 104–7
Spain 72–3
Sri Lanka *see* Ceylon
Sweden 2–3, 23, 61–65
Switzerland 74–5, 138
Syria 260, 265–7, 336
Tunisia 297–9
Turkey 4, 101, 103, 121–9
United States 82–4, 88–9
Vietnam 1, 4, 228, 230–2, 234–57

▼ Intrepid *autochromiste* Paul Castelnau in Egypt in 1918. A15907

Technical note

The archive photographs reproduced in this book were taken between 1908 and 1931 under a wide range of physical conditions. In order to remain faithful to the original material, electronic manipulation of the images has been kept to a minimum. Damage and blemishes have not been retouched.

The handful of autochromes with the letters 'AT' (à terminer) after their number were never fully developed. Scans of these images have been carefully enhanced for inclusion here.

Most of the autochromes are presented full-frame or close to full-frame. Images that have been significantly cropped are indicated with the word 'detail' in their caption.

Additional Captions

Page 1
Actors from the Saigon Theatre, Vietnam, photographed around November 1915. A7289 Léon Busy

Pages 2–3
A rower on Lake Siljan in Dalarna, Sweden, on 27 August 1910. A410 (detail) Auguste Léon

Pages 4–5
Top row, left to right
A family living on the outskirts of a Manchu village in China in June 1912. A774 Stéphane Passet
A Turkish lemonade vendor in Salonika, Greece, on 13 May 1913. A1981 (detail) Auguste Léon
A Zouave at Beaugency military hospital near Orléans, France, on 20 August 1915. A6796 Auguste Léon
A local dignitary engaged in official ceremonies in Tonkin, Vietnam, some time between 1914 and 1918. A10310 Léon Busy
A mahout aboard an elephant from a palace at Amber, near Jaipur, India, in December 1913. A4189 Stéphane Passet
Vodun practitioners in Zado, Dahomey, on 28 February 1930. A63560 Frédéric Gadmer

Bottom row, left to right
Mesdemoiselles Hélène and Denise Lauth of Massevaux in Alsace, France, on 6 July 1918. A14355 Georges Chevalier
A woman at a window overlooking the market square in Bayreuth, Germany, photographed around 1912. CL3 Auguste Léon
The Princess of the Khalkha Mongols on horseback in Ourga, Mongolia, on 23 July 1913. A3964 Stéphane Passet
Men working in the vineyards of the Château Pavie in St Emilion, France, in September 1920. A27299 Fernand Cuville
A fireman with unexploded ordnance in Reims, France, during the First World War. A11752-AT Fernand Cuville

Page 336
A car, probably Gadmer's, exits Wadi el Korn, a few miles northwest of Damascus. A29321 (detail) Frédéric Gadmer

Case boards (front) *Left to right, top to bottom*
Faiez Bey el-Sym, a supporter of Emir Faisal, photographed in Ghuwayr, Jordan, on 2 March 1918. A15506 probably Paul Castelnau
A pharmacist in Hanoi, Vietnam, in 1912. A9912 Léon Busy
Apprentice shoemakers at a French industrial college at Aleppo, Syria, on 7 October 1921. A29271 Frédéric Gadmer
Kahn's friend David Lévy-Kahn photographed at Boulogne-Billancourt, France, on 2 October 1926. A50107 Georges Chevalier
Rio de Janeiro, Brazil, *c.* August 1909. A69809 probably Auguste Léon
Bombay water-carriers, 17 January 1914. A4371 Stéphane Passet
A Farman reconnaissance biplane photographed at Tronquay, France, around 1916. A7241 Stéphane Passet
Two girls in Autun, France, in July 1916. A9415 Georges Chevalier
Three 'ladies of the night' in Jaffa, Palestine, on 15 August 1918. A15831 Paul Castelnau

Case boards (back) *Left to right, top to bottom*
Dahomey's King Agouloyé in January 1930. A63185 Frédéric Gadmer
A man selling lettuces, Salonika, Greece, on 13 May 1913. A1980 (detail) Auguste Léon
Buddhist pilgrims at Angkor, Cambodia. A35901 Léon Busy (*c.*1921)
Ruins of the peristyle at the Temple of Bacchus, Baalbek, Lebanon, in October 1921. A30101 Frédéric Gadmer
Mongol horsemen drawing an antiquated carriage at Ourga, Mongolia, on 19 July 1913. A3946 Stéphane Passet
Monsieur Quillie and Madame Nicolas of Penmarc'h, France, photographed on 29 February 1920. A20295 Georges Chevalier
An eel fisherman in Athlone, Ireland, photographed on 2 June 1913. A3677 Marguerite Mespoulet
French artillerymen at an observation post in Conchy-les-Pots, France. A5900 Stéphane Passet
Mademoiselle Bonnet photographed in Kahn's gardens at Boulogne-Billancourt, France, *c.*1911. A265 (photographer unknown)

Case boards (spine)
An Algerian leader, Taourirt Amokrane, Algeria, photographed *c.*1909–11. A18 (detail) Jules Gervais-Courtellemont

Sources and Further Reading

The information upon which this book relies was drawn from the following sources:

Allen, Charles, *Plain Tales from the Raj* (New Delhi: Rupa and Co., 1993)

Amad, Paula, 'Cinema's "Sanctuary": From Pre-documentary to Documentary Film in Albert Kahn's Archives de la Planète (1908–31)', *Film History*, 13.2 (2001)

Coe, Brian, *Cameras: From Daguerrotypes to Instant Pictures* (Gothenburg: Nordbok, 1982)

Ferguson, Niall, *The Pity of War* (London: Penguin, 1999)

Ferguson, Niall, *The War of the World: History's Age of Hatred* (London: Allen Lane, 2006)

Gernsheim, Helmut and Alison, *A Concise History of Photography* (London: Thames & Hudson, 1971)

Glenny, Misha, *The Balkans 1804–1999: Nationalism, War and the Great Powers* (London: Granta Publications, 2000)

Harding, Colin, *Autochromes: The Dawn of Colour Photography* (published at www.nationalmedia museum.org.uk/autochrome/pdfs/Autochromes%20-%20Dawn%20of%20Colour%20-%20essay.pdf)

Jacquier, Philippe, Pranal, Marion and Abdelouahab, Farid, *Le Maroc de Gabriel Veyre, 1901–36* (Paris: Kubik Editions, 2005)

Keegan, John, *The First World War* (London: Pimlico, 1999)

de Lécluse, Henri, *Comrades-in-Arms: The World War I Memoir of Captain Henri de Lécluse, Comte de Trévoëdal* (Kent, Ohio: Kent State University Press, 1988)

MacMillan, Margaret, *Peacemakers: The Paris Conference of 1919 and Its Attempt to End War* (London: John Murray, 2001)

Mak, Geert, *In Europe: Travels through the Twentieth Century* (London: Harvill Secker, 2007)

Mazower, Mark, *Dark Continent: Europe's Twentieth Century* (London: Penguin Books, 1999)

Moynahan, Brian, *The French Century: An Illustrated History of Modern France* (Paris: Flammarion, 2007)

Musée Albert-Kahn, *Albert Kahn 1860–1940: Réalités d'une Utopie* (Boulogne-Billancourt: Musée Albert-Kahn, 1995)

Musée Albert-Kahn, *Jean Brunhes: Autour du monde, regards d'un géographe/regards de la géographie* (Boulogne-Billancourt: Musée Albert-Kahn, 1993)

Roberts, Pamela, *A Century of Colour Photography* (London: André Deutsch, 2007)

Roberts, J. M., *Europe 1880–1945* (Harlow: Pearson Education, 2001)

Roberts, J. M., *The Penguin History of the Twentieth Century* (London: Penguin Books, 2000)

Rohdie, Sam, *Promised Lands: Cinema, Geography, Modernism* (London: British Film Institute, 2001)

Sassoon, Donald, *The Culture of the Europeans from 1800 to the Present* (London: HarperCollins, 2006)

Strachan, Hew, *The First World War* (London: Simon & Schuster, 2006)

Tombs, Robert and Isabelle, *That Sweet Enemy: The French and the British from the Sun King to the Present* (London: William Heinemann, 2006)

Totman, Conrad, *A History of Japan* (Oxford: Blackwell, 2001)

Tran, My-Van, *A Vietnamese Royal Exile in Japan: Prince Cuong De (1882–1951)* (London and New York: Routledge, 2005)

Whitfield, Peter, *Landmarks in Western Science from Prehistory to the Modern Age* (London: British Library, 1999)

Wilson, A. N., *After the Victorians* (London: Hutchinson, 2005)

Wood, John, *The Art of the Autochrome: The Birth of Colour Photography* (Iowa City: University of Iowa Press, 1993)

Winter, Jay, *Dreams of Peace and Freedom in the Twentieth Century* (New Haven and London: Yale University Press, 2006)

Zurcher, Erik J., *Turkey: A Modern History* (London: I. B. Tauris, 2001)

Acknowledgements

All history is based on selective reading, and I suspect that this book may be the fruit of an acquaintance with the historical canon even more limited than most. Nonetheless, I hope what I have written has at least a few functional virtues. The three main purposes of the text in this book are to contextualise the events that were filmed and photographed by Albert Kahn's *opérateurs*; to give an impression of the experiences they had on their travels; and finally to adumbrate the motivations of the man himself.

My pursuit of these objectives has been hampered by a number of disabilities, including a fairly demanding day job and a woefully inadequate command of French. For this reason, I am especially grateful to all members of the production team that offered such stalwart support during the making of the television series *The Wonderful World of Albert Kahn*, including Sophie Scott, Chiara Messineo, Kemi Majekodunmi, and especially Jasmine Dick, Krysia Derecki and Christina Lowry. I owe a special debt also to Keith Scholey, Basil Comely, Annie Corbett, Matt Ogden, Claire Miller, Charlie Gatward and to two colleagues in particular – my assistant Alex Duxbury, and Sue Davies, for her constant support during this and so many other projects over the years.

My debt extends to several dear friends and colleagues who generously (and unwisely) consented to review my early drafts. Georgina Godwin, Mike Poole, Julian Birkett, David Stewart and Sara-Lise Howe offered trenchant comment, perceptive criticism and constructive suggestions that helped to make the text in this book far less clunky and error-prone than it would otherwise be. I'm particularly grateful also to Mark Mazower, Anthony Clayton, Maria Misra, Giang Nguyen and Colin Harding for their acutely observed and incisive filtration of further solecism and blunder. This work is much improved because of their interventions and suggestions – although, of course, any deficiencies that remain are my responsibility alone.

It is by now mandatory for authors to express in the most fulsome terms gratitude for their publisher, but in the face of absurdly tight deadlines, the dedication, patience, organisational power and creativity of Christopher Tinker at BBC Books was never less than superlative.

The Wonderful World of Albert Kahn would not exist had BBC4's Controller, Janice Hadlow, and the corporation's Commissioner of Arts, Adam Kemp, not recognised the potential of Albert Kahn's story. I would also like to thank the BBC2 Controller, Roly Keating, who commissioned a reversioned form of the series for BBC2.

Ultimately, neither this book nor the TV series that inspired it would have been possible without the help of the Director of the Musée Albert-Kahn, Dr Gilles Baud-Berthier. Under Gilles' wise and inspirational leadership, ably supported by his colleagues – among others, Frédérique Le Bris, Ronan Guinée, Nathalie Clet-Bonnet, Jocelyne Leclercq-Weiss, Vladimir Pronier and Serge Fouchard – the Musée has established a position of pre-eminence among the cultural institutions in the *département* of Haut-de-Seine, and has become widely recognised as the repository of one of the most important collections of cultural artefacts in France.

Finally, for their unswerving patience, understanding and support, I must thank my dear mother Josie, whose personal generosity and lifelong dedication to humanitarian causes is in such sympathy with the underlying social and political orientations of the man who figures so strongly in this book, and my dear sisters Colly, Angie and Jacqui, whom I hope will forgive me for being even more uncommunicative than usual since I immersed myself in this project. Finally, I dedicate this work to my mother, the memory of my late nephew Linton, and to my brother Stephen, who passed away during the writing of this book.

Published to accompany the BBC television series *Edwardians in Colour: The Wonderful World of Albert Kahn* and *Twenties in Colour: The Wonderful World of Albert Kahn* first broadcast on BBC 4 in 2007.

First published in 2008 by BBC Books in association with the Musée Albert-Kahn, France.

BBC Books is an imprint of Ebury Publishing.
A Random House Group Company.

The Random House Group Limited Reg. No. 954009
Addresses for companies within the Random House Group can be found at www.randomhouse.co.uk

Text copyright © Woodlands Books 2008
All photographs copyright
© Musée Albert-Kahn 2008

10 9 8 7 6

Printed and bound in China
by C&C Offset Printing Co.,Ltd.

All rights reserved. No part of this publication may be reproduced, stored in a retrieval system, or transmitted in any form or by any means, electronic, mechanical, photocopying, recording or otherwise, without the prior permission of the copyright owner.

A CIP catalogue record for this book is available from the British Library.

ISBN 978 1 84607 458 5

Commissioning editor Christopher Tinker
Copy-editors Esther Jagger (text)
and Patricia Burgess (captions)
Designer Andrew Barron
Production David Brimble
and Helen Everson

www.albertkahn.co.uk